The Complete Minolta SLR Camera and Accessory Guide

Minolta Corporation
Ramsey, New Jersey

Photo Credits: All the
photographs in this book
were taken by the editorial
staff unless otherwise
credited. P. 3: L. Jones;
p. 4: J. Isaac.

Minolta Corporation
Marketers to the Photographic Trade

This book was created and
produced by Avalon Communications,
Inc. and The Photographic Book Co., Inc.

Library of Congress Cataloging in Publication Data
Main entry under title:

The Complete Minolta SLR camera and accessory guide.

 Includes index.
 1. Minolta camera. 2. Photography — Handbooks,
manuals, etc. I. Title: Complete Minolta S.L.R. camera
and accessory guide.
(Minolta Corporation)
TR263.M47C58 1983 771.3'1 83-6728

ISBN: 0-88041-001-9

Cover and Book Design: Richard Liu
Typesetting: Com Com (Haddon Craftsmen, Inc.)
Printing and Binding: W. A. Krueger Company
Paper: Warren Webflo
Separations: Spectragraphic, Inc.

Manufactured in the United States of America
10 9 8 7 6 5 4 3 2 1

Editorial Board

Contents

Technique Tips

Throughout the book this symbol indicates material that supplements the text and which has been set off for your special attention. You can apply the data and information in these Technique Tips immediately to get better results in your photography.

Introduction

The modern 35mm single-lens reflex camera is one of the most versatile and precise photographic tools ever devised. Advances in lens design, light-metering and exposure automation over the past 15 years or so have followed one another in increasingly rapid succession, providing photographers with image quality and ease of operation that was unimaginable a generation ago. In that time, a handful of photographic manufacturers throughout the world have succeeded not only in producing these highly sophisticated 35mm SLR cameras, but also in evolving entire photographic systems built around the cameras they make—systems that contain components capable of meeting virtually any picturemaking situation that can be thought of. This book takes a detailed look at the current system of single-lens reflex photography made by the Minolta Corporation, including its professional and amateur-oriented camera bodies, its extensive range of lenses and closeup accessories, electronic flash units, and various specialized meters for measuring ambient light, electronic flash output and color temperature.

The first camera made by what is now the Minolta Corporation was known as the Nifca. Introduced in 1929, the Nifca was a small, folding rollfilm camera with a German-made shutter and lens, but with a body and various other mechanical components made in Japan. During the 1930s, Minolta continued to produce a number of well-respected view cameras and rangefinder models. By the early 1940s the company had grown successful enough to establish its own optical plant, and in the postwar years expanded its endeavors to include the production of planetaria, projection equipment and various instruments for business and industry.

The first 35mm SLR made by Minolta—the SR 2—was offered to the public in 1958, featuring two components that were particularly advanced for the time. A quick-return mirror was one. The other component was a line of automatic-diaphragm lenses which would automatically stop down to the preselected shooting aperture just before the shutter was released, returning to the largest lens opening once the exposure was made.

Other innovations followed. The Minolta SR-7, released in 1962, was the world's first still camera incorporating a built-in CdS light metering system. A smaller, non-SLR Minolta accompanied America's first trip

Natural forms and textures are among the most satisfying of photographic subjects, and easy to capture on film with your Minolta SLR equipment. No matter what your photographic interests are, you will find the information you need on specific equipment and techniques in

into space the same year. Four years later, Minolta introduced the SR-T series of SLR cameras—one of the most successful and long-lived line of 35mm SLR models ever produced.

Throughout the 1960s and 1970s, various incarnations of the SR-T were introduced, including a fully professional, motorized model, the SR-M, which made its debut in 1970. In 1972 the X-series of Minoltas came into being with the XK (known in Europe as the XM). This sophisticated machine combined a host of professional features including through-the-lens metering and aperture-priority automation: the user chose a lens opening and the camera's electronics would then choose and set the appropriate shutter speed based on the lighting of the scene and the film speed. The XK also featured interchangeable focusing screens and viewfinders, making it adaptable to a host of specialized photographic situations. The XE-7, a slightly simplified and more compact model followed in 1974. This camera contained a vertical metallic shutter designed in collaboration with the German firm of Ernst Leitz, GMBH.

In 1977, Minolta introduced the XD-11. This was the world's first multi-mode camera, offering a choice of aperture-priority, shutter-speed priority and manual modes. The current X-series Minolta cameras are in

Local-focal-length lenses are necessary for moving in close to the action of spectator events, but you will have to decide whether you prefer a conventional fixed-focal-length telephoto, a zoom lens, or even a mirror lens. The chapter on lenses will help you make this decision, and specific information on photographing sports may be found in chapter 6. Photo: L. Clergue.

Perfectly exposed shots like this are easy to get once you understand the basics of film characteristics and exposure techniques. See chapter 3 for further information.
Photo: L. Jones.

many ways direct descendants of the XD-11 and earlier models, although they make use of technology that just a few years ago did not exist. Such items as integrated-chip electronics, quartz-controlled timing and computerized electronic flash capability make the current Minolta cameras more accurate, durable and easy to use than ever before. Coupled with the Minolta system's high-quality lenses, these cameras provide amateurs and professionals alike with picturemaking tools capable of the very highest image quality.

The chapters that follow discuss the Minolta SLR system of photography in detail, both in terms of the specifications of the items available and in terms of how they can be best used to help you get exactly

1

The Cameras

The Minolta SLR photographic system is one of the most extensive in the world, with over 400 different components designed to help photographers effectively meet any picturemaking challenge imaginable. At the foundation of the system lies a series of highly advanced cameras, each designed with specific photographic needs in mind. For the novice photographer who does not want to be concerned with making his or her own shutter-speed settings, but who does require the excellent image quality provided by Minolta's comprehensive group of lenses, there is the XG-A, a compact, electronic camera with automatic exposure and simplified operating controls. For the advanced amateur and the professional who needs a light, precise automatic camera with fully controllable exposure override, there are Minolta's aperture-priority models with a full range of manually set shutter speeds for use in difficult lighting situations.

At the top of the line is the X-700, a multi-mode automatic SLR with such sophisticated, professionally oriented features as programmed automation, off-the-filmplane flash automation and compatibility with a specially designed Multi-Function back that can be used to imprint data or to fire the camera at various predetermined intervals and speeds.

Each of the cameras in the Minolta SLR system has well-placed, easily manipulated controls. The "human engineering" concerns evident in their construction allow the cameras to become a virtual extension of the hand; you can concentrate on making your picture rather than on using the camera.

The following pages describe in detail all of the SLRs in the Minolta system. Each of them is capable of thoroughly professional results, and is compatible with virtually all of the components of the system.

Your Minolta 35mm camera will enable you to take beautiful photographs wherever you go. Superb engineering and a wide variety of interchangeable accessories make complicated manipulations unnecessary, so you can concentrate on making the pictures themselves. Photo: J. Isaac.

Basic SLR Operations

The modern 35mm single-lens reflex camera (SLR) is an extremely efficient and versatile picturetaking tool for a number of reasons: it has a large selection of interchangeable lenses at its disposal; there are many types of film available for it; various types of built-in automatic exposure systems provide perfect exposures in all sorts of lighting. However, while each of these attributes plays a role in the camera's popularity, its success is probably due most to the fact that it lets you see your subject through the same lens that makes the picture.

How can a camera use the same lens to both show you your subject and record it? It may not be magic, exactly, but it does involve the use of mirrors. As light passes through the lens, it strikes a mirror set at a 45-degree angle in the camera body. The mirror reflects the light upwards onto a focusing *screen*—a piece of plastic or finely ground glass, positioned exactly where it shows a sharp rendition of the scene when the lens is precisely focused.

Sitting on top of the screen is a *pentaprism*. This highly polished, five-sided block of glass bends the light rays reflecting from the screen image, sending a right-side-up rendition of the subject through the camera's eyepiece to your eye. This arrangement works no matter what lens is mounted on the camera; you see your subject in precisely the same way as the lens will record it.

All of Minolta's SLRs have extremely bright, easily read focusing screens and virtually foolproof loading mechanisms, as well as a number of other fail-safe systems that make it practically impossible to miss any of those once-in-a-lifetime shots — like these saris drying in the Indian sun. Photo: J. Isaac.

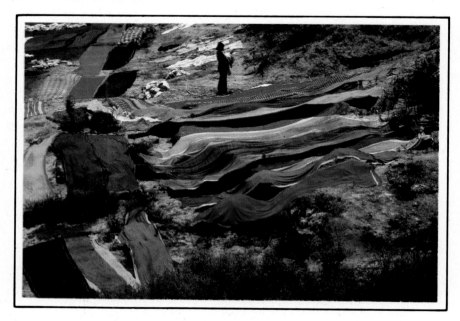

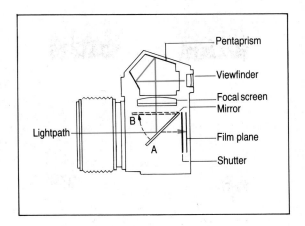

In the viewing system of an SLR camera, an angled mirror (in position A) reflects the image formed by the lens onto the focal screen. As the image, which is reversed, passes through the pentaprism, it is turned right-side-around so that it appears correct in the eyelevel viewer. When the shutter is activated, the mirror moves up to position B, so the light can fall on the film plane to make the exposure.

So far, so good. But how does the image get around the viewing system so that it can be recorded on your film? The reflex mirror is hinged, and controlled by a series of of springs and levers that work in coordination with the exposure controls.

When you press the shutter-release button, the mirror flips up out of the lightpath. As this happens, a *focal-plane shutter* near the film opens at a predetermined speed, letting the light reach your film. Once the exposure is made the shutter closes and the mirror drops back down into the lightpath; you can now repeat the procedure all over again.

All of this takes far less time to occur than it does to explain. Modern reflex mechanisms are so precisely constructed and coordinated that the entire series of events takes place in less than half a second—unless, of course, the shutter speed in use is slower than that.

Besides showing you the subject, SLR viewing systems provide information about exposure settings. All modern Minolta SLRs have through-the-lens metering—a built-in light meter that determines the exposure needed for your picture by reading the light coming from the focusing screen. This information is provided via a series of light-emitting diodes (LEDs): little lamps that glow alongside the shutter speeds required for accurate exposure. Other LEDs indicate whether or not the automatic exposure controls of the camera are in use; still others warn of possible over- or underexposure, and tell you when certain electronic flash units are ready for use.

The single-lens reflex camera has one minor drawback: because the mirror moves upward during exposure, it blocks your view of the subject while the exposure is taking place. The momentary "blink" that occurs is so short that most photographers get used to it almost at once. In any event, the focusing and exposure-control advantages of modern single-lens reflex systems far outweigh the small inconvenience of a moving mirror.

The Minolta XG-A*

The completely automatic, aperture-priority XG-A is an extremely simple-to-use 35mm SLR which has many of the features found on Minolta's professionally oriented cameras. The XG-A's through-the-lens, center-weighted metering system combines with its electronically governed shutter to provide accurate stepless speeds from 1 sec. to 1/1000 sec. based on the lens opening you have set and the amount of light reflecting from your subject. A non-automatic "B" setting is provided for exposure times longer than 1 sec.

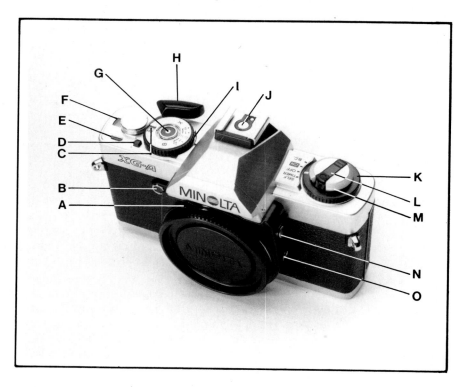

A *MC coupler lug;* **B** *Self-timer/battery check indicator;* **C** *Film-speed window;* **D** *Auto-setting release;* **E** *Safe-load signal;* **F** *Frame-counter window;* **G** *Touch-switch/operating button;* **H** *Film-advance lever;* **I** *Shutter-function selector;* **J** *Hot shoe;* **K** *Main switch;* **L** *Rewind crank;* **M** *Back-cover release knob;* **N** *Lens-release button;* **O** *Shutter-release socket.*

The XG-A is powered by two 1.5-volt silver-oxide batteries (S76, D76 or equivalent). These supply the energy needed for all of the camera's operating controls. A large red LED on the XG-A's frontplate serves as a battery check indicator as well as a self-timer warning.

*The camera designated XG-A may not be generally distributed in Europe or the United Kingdom.

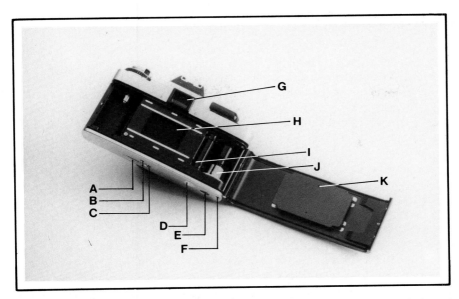

A *Battery-chamber cover;* B *Winder terminal;* C *Tripod socket;* D *Rewind button;* E *Auto-winder coupler;* F *Guide-pin socket;* G *Finder eyepiece;* H *Shutter curtain;* I *Sprocket;* J *Take-up spool;* K *Pressure plate.*

The camera's main power/battery-check/self-timer switch is at the base of the rewind knob. Keep this switch in its "OFF" position when not using the camera, to lessen the chance of battery drain. To check battery condition, move the switch to its "B.C." position, and watch the large red LED on the front of the camera. If the LED glows, the batteries have enough power for proper operation. You can now turn the switch to its "ON" position for shooting.

The mode dial of the XG-A is just to the right of the prism, with the camera in shooting position. This dial has three settings: "AUTO" for automatic, aperture-priority exposure; "B" for long exposures; and "X" for the 1/60-sec. speed needed to manually synchronize non-automatic electronic flash units. The mode dial also has settings for automatic exposure override of \pm 2 stops, for backlighted subjects and

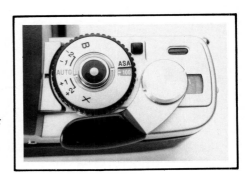

The XG-A's mode dial has three settings: "B", "X" and "AUTO", and exposure override settings of \pm 1 and \pm 2 stops. The knurled outer ring may be lifted to change the film speed settings.

other situations where exposure may present special problems. The rim of the mode dial is heavily knurled, making it easy to grip. Raising this rim will let you set the speed of your film into the camera's metering system. Speeds from ISO 25/15° to 1600/33° can be set by turning the dial's rim until your film speed appears in a small window atop the dial. The speeds are numbered in full stops throughout the metering range; intermediate settings in increments of ⅓-stop can be set between the numbered speeds. (For a more detailed explanation of film speed rating systems, see the section "Film Types and Qualities" in chapter 3.)

The XG-A is an *aperture-priority* automatic camera: the photographer chooses a lens opening (aperture) and the camera sets an appropriate shutter speed. The speed chosen is displayed via LEDs in the camera's viewfinder, just outside of the picture area. The danger of overexposure or underexposure is also indicated by LEDs above and below the shutter-speed LEDs, respectively.

The exposure compensation dial will let you adjust the automatic exposure system's decisions by \pm two stops, steplessly or in half-stop increments. This feature is especially useful in backlighted situations, when the illumination behind the main subject might overly affect the XG-A's meter, resulting in an underexposed rendition of the most important part of the scene. You can overcome this difficulty by turning the mode/compensation dial until the selector at its left aligns with the +1 or +2 before making your exposure. The dial locks in place at its "AUTO" setting, to keep you from accidentally keying in the exposure compensation control. To release the dial, press in a small locking button at its right as you turn.

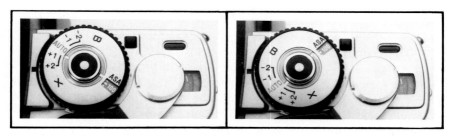

The exposure compensation features of the XG-A let you adjust for situations where a scene's general lighting conditions would result in over- or underexposure of the main subject. To add exposure to the main subject, turn the knob to one of the plus settings (left); to decrease exposure, turn to a minus setting (right).

In situations where the background is substantially darker than the main subject, the unadjusted automatic exposure system might cause underexposure in important features. To counteract this, set the exposure-compensation dial to its −1 or −2 setting. Half-stop settings between the marked numbers let you make finer adjustments.

The XG-A's viewfinder contains Minolta's bright and contrasty Acute Matte focusing screen, with a rangefinder wedge surrounded by

a microprism band at its center. These devices, along with the "snappiness" of the screen itself, make focusing of the lenses in the Minolta system quick and positive. The screen shows 93 percent of the image recorded.

The XG-A will provide automatic flash exposures with any X-series Auto Electroflash unit. Special contacts in the camera's flash shoe mate with those in the foot of the flash unit to automatically set the 1/60-sec. synchronization speed, and to indicate that the flash is ready to fire; an LED next to the 1/60-sec. speed indicator in the finder will blink when the flash unit is fully charged. For proper synchronization with Minolta's manual flash and other maker's electronic flash units, the exposure-mode dial must be turned to its "X" setting.

Besides the extensive series of Minolta Auto Electroflash units, the XG-A accepts a number of other capability-expanding accessories: the Autowinder G, which provides automatic single-frame film advance that lets you shoot quickly without having to take the camera away from your eye to advance the film; electronic remote cords for vibration-free remote firing at distances up to 5m (16½ ft); and the wireless controller IR-1 which uses infrared beams to trigger the shutter from distances as far away as 61m (200 ft).

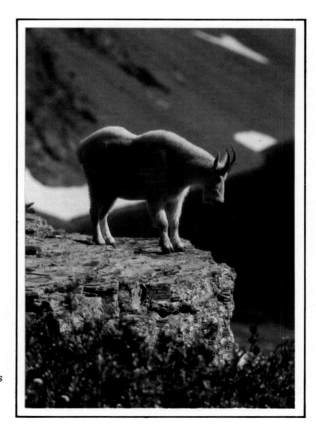

Backlighting is a difficult exposure situation; a camera's averaging meter, reading from the overall scene, would not take into consideration the fact that part of the subject is in shadow. The result would be silhouette with only the background properly exposed. Increasing the exposure may result in some overexposure of the background, but the details of the main subject will be more readily revealed. Photo: M. Fairchild.

The Minolta XG-1

The XG-1 is Minolta's easiest to use and most economical dual mode SLR, giving photographers a choice of aperture-priority automatic operation or fully manual exposure control. In keeping with the rest of the Minolta system, the XG-1 is a compact, streamlined camera with large, easily accessible operating controls. Most of the XG-1's functions can be activated and changed without having to remove the camera from your eye.

The shutter of the XG-1 is fully electronic, providing stepless speeds from 1 sec. to 1/1000 sec. in its automatic mode, and stepped speeds over the same range when the speeds are set manually. The exposure system is specially designed to lock the shutter if the lighting

A *MC coupler lug;* **B** *Self-timer/battery check indicator;* **C** *Shutter-speed/function selector;* **D** *Auto-setting release;* **E** *Safe-load signal;* **F** *Frame-counter window;* **G** *Touch switch/ operating button;* **H** *Film-speed window;* **I** *Film-advance lever;* **J** *Hot shoe;* **K** *Back-cover release knob;* **L** *Rewind crank;* **M** *Main switch;* **N** *Lens-release button;* **O** *Shutter-release socket;* **P** *X-sync terminal.*

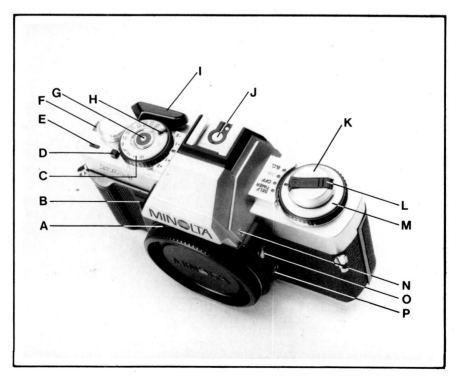

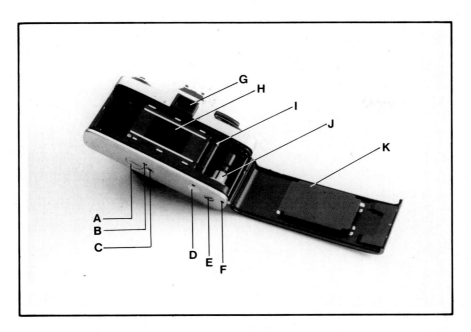

A *Battery-chamber cover;* B *Winder terminal;* C *Tripod socket;* D *Rewind button;* E *Auto-winder coupler;* F *Guide-pin socket;* G *Finder eyepiece;* H *Shutter curtain;* I *Sprocket;* J *Take-up spool;* K *Pressure plate.*

conditions and the aperture you have set call for a shutter speed faster than the camera's top 1/1000 sec. speed. A "B" setting is also provided for shutter speeds slower than 1 sec.

Power for all of the XG-1's metering and shutter operations is drawn from two 1.5-volt silver-oxide batteries housed in the camera's baseplate. To help you avoid improperly exposed photographs, the shutter will lock if the battery power is too low for proper metering.

The XG-1's metering system will provide accurate center-weighted exposure readings for all film speeds from ISO 25/15° to 1600/33°. The meter's shutter-speed settings or recommendations can be seen at the right of the focusing screen, just outside of the picture area. Speeds from 1/1000 sec. to 1/30 sec. are shown numerically. Three dots under the 1/30 sec. marking show that speeds between 1/15 and 1/2 second are being set. The 1-sec. shutter speed is also indicated by number. LEDs light up alongside the dots and numbers to show the speed in use. In addition, triangular LEDs above and below the shutter speeds warn of over- and underexposure respectively. When the XG-1 is used with a Minolta Auto Electroflash X, the 1/60 sec. LED will pulsate to let you know that the flash unit has fully recycled.

The aperture-priority XG-1 allows you full control over the exposure of your photograph, so you can take advantage of the dramatic possibilities of many lighting situations. What you don't have to worry about is the shutter speed, which is set automatically according to the aperture you have selected. You can concentrate on taking pictures without removing the camera from in front of your eye. Photo: P. Bereswill.

The non-interchangeable Acute Matte focusing screen of the XG-1 shows 93 percent of the total film frame area—you see as much of the image as you would in a mounted slide. The screen has a horizontally situated split-image rangefinder wedge at its center, surrounded by a microprism collar. These aids provide easy focusing with all of Minolta's lenses in a variety of lighting conditions.

The shutter-speed/mode dial of the XG-1 is part of a small "control center": the knurled ring of the dial can be raised to set the film speed in a small window cut between the "A" and 1/1000 sec. markings. An exposure compensation setting scale is located between the shutter-speed/mode dial and the pentaprism. The scale is marked from +2 to −2 in full stop increments, with an index line at the center of the scale to indicate unadjusted automatic exposure.

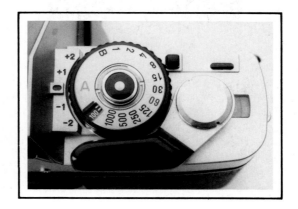

The XG-1's shutter-speed/mode dial performs a variety of functions. In the automatic mode, aligning the red "A" with ± 1 or ± 2 allows you to compensate for difficult exposures. Shutter speeds from 1 sec. to 1/1000 sec., and "B," may be selected for use in the manual mode. By raising the knurled outer knob, you can change the film-speed settings.

The main power switch of the camera is on a dial surrounding the base of the rewind knob. The dial has settings for battery check and self-timer activation along with power "on" and "off" positions.

With the main power switch set to "on" and the shutter-speed/mode control at its "A" position, the XG-1 will choose the appropriate shutter speed based on the aperture you have selected and the amount of light reflecting from your subject. A light touch of the shutter-release button will activate the shutter-speed LEDs in the finder. If the light is too bright or too dim to let the camera's electronics set a shutter speed in its range, the triangular over- or underexposure LED will blink; if this happens, choose a lens opening that will bring the shutter within range.

The LEDs indicating shutter speeds will light only if the XG-1 is in its automatic mode. A red "M" LED will light to remind you that the camera is not automatically providing the correct exposure setting. To use the camera's metering system for meter readings even if you are setting your own shutter speeds, set the mode selector to "A," read the LED-indicated speed in the finder, then set the speed shown on the shutter-speed dial.

The XG-1 has an electronic self-timer with a 10-second delay. A large red LED pulsates on the camera's frontplate when the self-timer is in use. The pulsing increases in speed to indicate that the shutter is about 2½ seconds away from going off.

The entire line of over 50 lenses and most of the other components of the Minolta system can be used with the XG-1. These include the Autowinder G and the X-series Auto Electroflash units, which electronically set the 1/60 sec. shutter speed needed for proper flash operation and cause the 1/60 sec. LED to blink when the flash is fully charged.

The Minolta X-700

The X-700 is the cornerstone of the Minolta SLR system. It is a compact, lightweight camera featuring fully programmed automation; programmed auto-flash with exposure readings made off the film surface at the moment of exposure; aperture-priority automation; and fully metered manual exposure. All of the pertinent exposure information can be seen in the viewfinder, along with over- and underexposure warnings, a flash-ready signal, and indicators warning you that you have set the automatic exposure lock and/or the exposure compensation dial. A cancellable audible warning is also provided, to warn of possible camera shake should the shutter speed fall below 1/60 sec.

A *MD coupler;* **B** *MC coupler;* **C** *AE lock/self-timer switch;* **D** *Main switch;* **E** *P/A lock release;* **F** *Safe-load signal;* **G** *Frame counter;* **H** *Touch-switch/operating button;* **I** *Film-advance lever;* **J** *Main-switch position indicator;* **K** *Flash/camera-control contacts;* **L** *Sync contact;* **M** *Exposure-adjustment control release;* **N** *Back-cover release knob;* **O** *Film-speed window;* **P** *Rewind crank;* **Q** *Film-speed ring;* **R** *Lens-release button;* **S** *Shutter-release socket.*

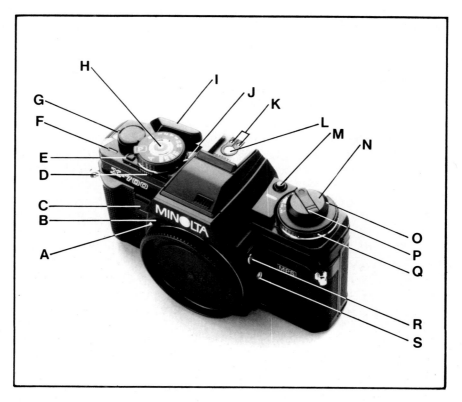

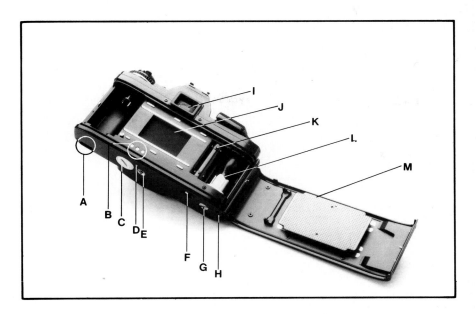

A *Motor-drive guide socket & contacts;* **B** *Contact terminals for Multi-Function Back;*
C *Battery-chamber cover;* **D** *Winder contact;* **E** *Tripod socket;* **F** *Rewind release;*
G *Winder/motor-drive coupler;* **H** *Winder/motor-drive guide socket;* **I** *Finder eyepiece;*
J *Shutter curtain;* **K** *Sprocket;* **L** *Take-up spool;* **M** *Pressure plate.*

Besides accepting all of the lenses and virtually all other components of the Minolta SLR system, the X-700 has a number of accessories all its own, including a programmed dedicated flash unit, an infrared remote firing system and a multi-function back that allows you to preset the camera for unmanned firing or for time exposures ranging from 1 sec. to 100 hours. The multi-function back can also be made to imprint data onto the film either during exposure or directly afterwards.

The horizontally traveling, cloth focal-plane shutter of the X-700 provides stepless speeds from 4 sec. to 1/1000 sec. in its automatic modes and discrete speeds from 1 sec. to 1/1000 sec. when the X-700 is used as a manual-exposure camera. A "B" setting is provided for long time exposures. The X-700's shutter is electronically governed, as is its shutter release, which locks automatically when there is not enough battery power to let the camera function properly.

Two silicon photo cells provide metering for the X-700. One of these is located behind the pentaprism, providing through-the-lens, center-weighted exposure readings in ambient light. The other is in a special housing under the mirror, situated to give accurate off-the-film flash readings when the X-700's 280 PX dedicated flash unit is in use. The metering system can be set for films ranging in speed from ISO

25/15° to 1600/33°. Automatic exposure settings can be modified by way of an exposure compensation dial that allows +2EV adjustments in ⅓-stop increments. An automatic exposure-lock switch on the X-700's frontplate allows you to hold closeup settings for accurate exposure in difficult lighting.

All of the X-700's operating controls are powered by two 1.5-volt silver-oxide or alkaline/manganese batteries (S76, MS76 or equivalent), which fit into a compartment in the camera's baseplate. The main power switch of the X-700 has three positions: " ON ⑴) ", which activates all of the camera's electronic systems, including an audible slow shutter-speed and self-timer warning; "OFF"; and "ON," which turns on all operating controls excepting the audible signal.

The shutter-speed/mode dial has marked speeds from 1 sec. to 1/1000 sec. and "B," along with an "A" setting for aperture-priority automation, and a "P" setting for fully programmed automatic exposure. The dial locks at its "A" and "P" settings, and can be released by a small unlocking button. The dial surrounds a "soft-touch" shutter release; lightly touching this release button will activate the metering system and viewfinder display for 15 seconds.

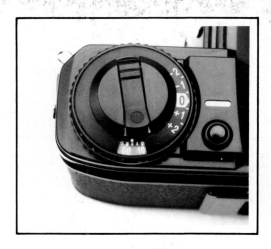

The X-700's film-rewind dial performs two other important functions. The film-speed setting is adjusted by turning the outer knurled knob. The dial is also used to make exposure compensations of ±1 or ±2 stops when the camera is in either the "A" or "P" modes.

The X-700 is easiest to use as a fully programmed automatic-exposure SLR. The camera's metering and exposure-setting controls read the light reflecting from the subject and set the appropriate shutter-speed/aperture combination. This leaves you free to devote your attention to your subject. The program mode of the X-700 is unique in that it is "shutter-weighted"; that is, it will choose the fastest shutter speed possible under the lighting conditions you are working in. The shutter speed chosen by the program can be seen in the finder at all times.

In its programmed mode, the X-700 does all the work of selecting appropriate shutter speed/aperture combinations, leaving you completely free to concentrate on your subject. Because the program mode is shutter-weighted, it will choose the fastest shutter speed possible under the available lighting conditions — a great advantage with most subjects that are not completely stationary. Photo: B. Sastre.

The program mode also works in conjunction with Minolta's 280 PX dedicated flash unit, setting the synchronization speed of 1/60 sec. and the appropriate lens opening, according to how much light there is in the scene.

To use the X-700 in its program mode, set the shutter-speed/mode dial to "P," and your MD lens to its minimum aperture. New MD lenses have a minimum aperture lock to keep the lens from accidentally slipping to a wider opening. If the lens is not set to its minimum aperture, the green "P" in the finder will blink constantly. Under most circumstances, the program mode will work properly even if the lens is not at its minimum aperture; but to take advantage of the program mode's full range, keep the lens closed down as far as it will go.

If you want to have full control over depth of field, or want the slower shutter speeds obtained at smaller apertures, use the X-700 in its aperture-priority automatic mode. The "A" mode will automatically select and set the proper shutter speed based on the lens opening you

have chosen to use. Because it does not require the lens to be set at its minimum aperture, the "A" mode can be used with non-MD lenses, closeup bellows units, and other special purpose lenses which cannot be coupled to the programmed exposure mode.

The "A" mode of the X-700 provides automatic flash exposures at any lens opening with the Auto Electroflash 280 PX and CLE, and automatic exposures at various apertures with other Auto Electroflash X-series units. With all X-type units and the CLE flash, the X-700's shutter speed will be set automatically to 1/60 sec. in the "A" mode.

For aperture-priority photography with the X-700, set the shutter-speed/mode dial to its "A" position, choose an aperture, focus and shoot. Warning arrows in the finder will tell you if the aperture you have set is too large or small for the exposure mechanism to set an appropriate shutter speed.

The camera's settings can be overridden in either "P" or "A" modes. A small switch on the frontplate functions as a combined self-timer/auto-exposure locking button. When this button is held down, the camera's settings will be locked in place, making closeup exposure readings simple. An exposure compensation dial under the X-700's rewind knob can be set to adjust the camera's automatic settings by \pm 2 stops, steplessly or in half-stop increments. This dial is especially useful in strongly backlighted situations or under other conditions where extremely light or dark backgrounds might cause incorrect exposure of your main subject.

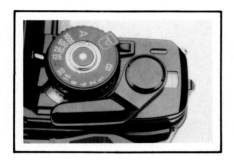

The X-700's shutter-speed/mode dial controls almost all the camera's exposure functions. The "P" setting is for the fully programmed, automatically set aperture/ shutter-speed mode. When set on "A," the aperture-priority automatic mode is in operation. For full manual control, the dial is used to select shutter speeds from 1 sec. to 1/1000 sec. or "B" for longer exposures. At the center of the dial is the shutter-release; a light touch activates the metering system and viewfinder display; a firmer touch releases the shutter.

For complete creative control of exposure settings, the X-700 has a fully metered manual exposure mode. A full range of shutter speeds, from 1 sec. to 1/1000 sec. can be set on the shutter-speed/mode dial. With the main power switch on and the shutter-speed dial set at any of the indicated speeds, a red "M" lights up in the finder to remind you that the camera's automatic controls are not being used. The meter will continue to indicate the correct shutter speed; you may follow its advice by setting the shutter dial to the speed indicated, or by moving the lens aperture ring until the shutter speed you want to use appears in the finder display; or you may ignore the meter's advice altogether, setting whatever shutter speed/aperture combination you feel will produce the kind of picture you are after.

In manual mode, the beep warning of speeds below 1/30 sec. indicates the shutter speed suggested by the metering system, regardless of the speed you have set.

Besides the slow-shutter-speed warning, flash-ready signal and auto-exposure override warning in the finder, the X-700 features a flash-distance checking signal to let you know that your subject is within range of the flash unit.

The X-700's self-timer is electronic, providing both visual and audible signals that it is engaged. A large LED on the camera's frontplate pulses steadily, accompanied by a beep (which can be cancelled). The pulse rate of the LED increases about two seconds before the shutter is ready to fire. The self-timer can be canceled at any time during its 10-second cycle.

The optional Multi-Function back can be used with the X-700 for a variety of purposes. It can be used to take long exposures controlled by a built-in quartz timer, to take unmanned time-lapse sequences (with motor drive or winder) at a range of intervals, or both. The quartz timer and auto calendar automatically imprint the time down to a second; the year, month and day; any six-digit code number; or the consecutive frame number.

The X-700 is fully compatible with a series of professionally oriented accessories. Eight different viewing screens, besides the standard one, are available; each can be installed by an authorized dealer. The Motor Drive 1, which provides single-exposure advance and sequential advance up to 3.5 frames per second, mates with the X-700 without any factory modification, as does the smaller Autowinder G, which can be used for automatic film advance after each exposure without having to take the camera away from your eye. These components, along with the multi-function back, infrared remote control set, bellows units and numerous Minolta lenses, allow you to adapt the X-700 to virtually any photographic task you are likely to assign it.

The Minolta X-570 *

The X-570 is a compact, electronic SLR combining aperture-priority automation with fully metered, match-LED manual exposure control. As an integral part of the Minolta system, it is compatible with all MD and MC type lenses, the professionally oriented Motor Drive 1, the Auto Winder G, Minolta's PX series and other Auto Electroflash electronic flash units, and virtually all other components of the system.

In addition to the automatic and metered manual exposure controls for ambient light photography, the X-570 offers through-the-lens flash metering when used with PX flash units. This combination provides automatic off-the-film flash control at any aperture.

The X-570's electronically governed and quartz-timed focal-plane shutter is stepless from 4 sec. to 1/1000 sec. in its automatic mode, giving extremely accurate exposures even if the lighting calls for the use of an intermediate speed.

If you want complete control of all exposure settings, the manual mode of the X-570 will let you set any discrete speed from 1 sec. to 1/1000 sec., plus "B" for long exposures.

A *MC coupler lug;* **B** *AE lock/self-timer;* **C** *Auto-setting release;* **D** *Safe-load signal;* **E** *Film counter;* **F** *Touch-switch operating button;* **G** *Film-advance lever;* **H** *Shutter-speed/function selector;* **I** *Flash/camera-control contacts;* **J** *Sync contact;* **K** *Main switch & position indicator;* **L** *Film-speed ring release;* **M** *Rewind crank;* **N** *Back-cover release knob;* **O** *Film-speed ring;* **P** *Lens-release button;* **Q** *Shutter-release socket.*

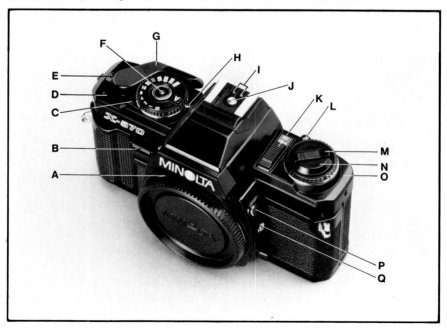

*In Europe and the United Kingdom, this camera is designated X-500.

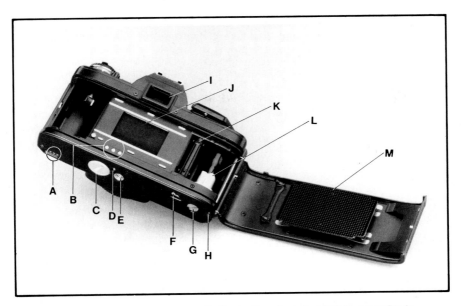

A *Motor-drive guide socket & contacts;* B *Contact terminals for Multi-Function Back;*
C *Battery-chamber cover;* D *Winder contact;* E *Tripod socket;* F *Rewind release;*
G *Winder/motor-drive coupler;* H *Winder/motor-drive guide socket;* I *Finder eyepiece;*
J *Shutter curtain;* K *Sprocket;* L *Take-up spool;* M *Pressure plate.*

Metering for both the aperture priority and manual exposure modes is done via a silicon photocell mounted in the camera's pentaprism. While the cell measures the light reaching the camera from the entire picture area, it is designed to concentrate its readings towards the center of the scene. This center-weighted system greatly reduces the chance of exposure error that may result when there are areas in the scene that are brighter than the main subject (bright skies, for example). Thus the X-570 helps avoid a major cause of underexposure, one that occurs fairly often in cameras with simple averaging metering. The camera's meter can be set for film speeds from ISO 12/12° to 3200/36°. The film speed dial is numbered in full stops throughout this range, with small lines indicating ⅓-stop intermediate settings.

The X-570's automatic, through-the-lens flash metering is determined by a second silicon cell located beside the mirror compartment.

Power for all of the X-570's electronic functions is supplied by a pair of 1.5V silver oxide or alkaline manganese batteries (S 76, MS 76 or equivalent). A single 3V lithium battery may also be used. The batteries activate the camera's "touch switch" shutter release, which doubles as a meter-activating switch. When the camera's main power switch is turned on, a gentle touch on the shutter-release button will activate the metering circuits. The shutter release will lock automatically if there is insufficient battery power for proper operation. The camera's metering system provides accurate exposures from EV 1 to EV 18 (1 sec. at f/1.4 to 1/1000 sec. at f/16 with ISO 100/21° films).

The X-570 viewfinder contains a series of LEDs that light up alongside shutter speed numbers at the right of the picture area. A pair of triangular LEDs, one at the top and the other at bottom of the display, provide over- and underexposure warnings when needed.

The mode in use is signalled by LEDs as well: an "A" will light when the camera is in its auto mode; "M" lights when the manual exposure mode is being used. Some of the LEDs serve a double purpose: the underexposure LED will blink to warn of insufficient illumination, and will glow steadily when the camera is in its automatic mode and the shutter speed being set by the auto exposure system is between 1 and 4 sec. Shutter speeds slower than 1/30 sec. are accompanied by an audible beep, to warn of possible camera shake. The tone can be turned off for those times when you need no warning.

When the mode indicator LED blinks, it is a warning of low battery power. Should this occur, replace the batteries as soon as possible. A * shaped LED next to the "B" setting in the scale lets you know that the shutter has been set to "B".

The X-570 is an ideal camera for the traveler. Light, compact and easy to hold and operate, it offers both aperture-priority automation and manual control and is compatible with virtually all other components of the Minolta system. This versatility under a tremendous variety of picture-taking situations makes the camera a perfect tool any time or any place. Photo: J. Isaac.

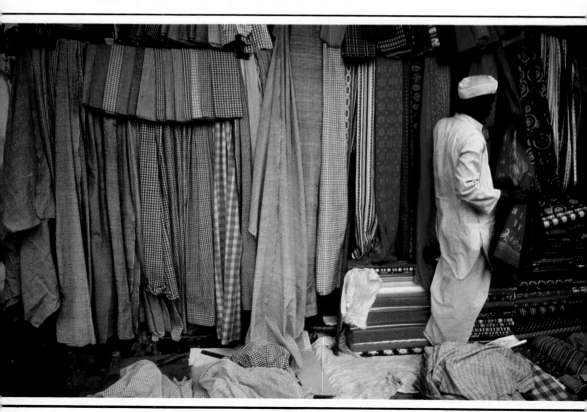

With the camera in manual mode, an LED will blink to indicate the manually set shutter speed, while another indicating the recommended speed will glow steadily. Thus, accurate manual exposures are as simple as moving the shutter speed dial or the lens aperture until the blinking LED goes out or is replaced by a steady glow.

Besides the LED indicators, the X-570's viewfinder displays the aperture in use—provided you are using a Minolta MD or MC lens. The display and metering will continue to function for 15 seconds after the touch switch is activated, and will then turn itself off automatically.

The X-570 has an electronically controlled self timer, providing a cancellable delay of 10 seconds. The timing sequence is indicated by an audible signal and a flashing LED on the camera front, directly under the self-timer switch.

The Acute-Matte screen of the X-570 is oversized, exhibiting no cutoff even with extremely long telephoto lenses. The screen itself is one of the brightest made, with a central rangefinder spot surrounded by a microprism collar to increase focusing ease in various lighting conditions. Seven other screens are available as factory-installed options, to provide even more efficient focusing in specialized applications.

The X-570 body is designed to be held comfortably and operated with ease. All of the controls are laid out in an uncluttered, functional manner and can be manipulated without taking the camera away from the eye. Built along the same design lines as the X-700, the X-570's body has a textured, sculptured grip along its back for comfortable, slip-free holding.

The aperture-priority mode of the X-570 provides accurate exposure with all sorts of lenses, bellows, and other devices. In this mode, you choose the aperture while the camera's exposure and metering system measures the light and chooses an appropriate shutter speed. An auto-exposure lock button is provided to facilitate closeup readings or accurate exposure in difficult lighting situations. The lock button will allow you to take a closeup reading of the most important part of the subject, then hold the appropriate setting in place as you step back to recompose the photograph.

With any PX-series Minolta flash unit attached, the X-570 becomes an off-the-film-plane metering, automatic flash camera. Since the metering cell for flash is located where it can make readings directly off the film, accurate exposure is virtually guaranteed under all sorts of light, with all apertures. The film speed setting of the PX-series flash unit is taken from the camera when the X-570 is set to its "A" mode. If the light is sufficient for accurate flash exposure, the LED alongside the 1/60-sec. shutter speed in the finder will blink rapidly.

The X-570 can be equipped with the professional Motor Drive 1, the compact winder G, a data back, the wireless controller IR-1 and most other accessories in the Minolta system, making it one of the most versatile picturemaking tools in Minolta's arsenal.

Loading Film

All of the cameras in Minolta's SLR system have essentially the same easy loading features. Loading your Minolta with film is quick and trouble free, if you take the following simple steps and precautions.

Loading. If you are loading your Minolta for the first time, read the instruction booklet carefully and practice with a "dummy roll"—an outdated roll of film you can get cheaply from your photo dealer.

Always load your camera in subdued light. If you happen to be outside in bright sunlight, find some shade under a tree, canopy or doorway. Failing that, shield the camera from excess light by turning your back to the sun and loading in your own shadow.

Put a cap on your lens to protect it while you load. Set your camera's shutter/mode selector to a high manual speed, or to its "X" setting. This will prevent unneccessary battery drain that might occur if you tried to load the camera while it is set on an automatic mode.

To open the camera, raise the rewind knob until the camera back pops open. Keep the rewind knob pulled up as you insert a film cartridge into the chamber underneath it. The end of the film cartridge with the protruding spool must be pointed downwards.

Once you have seated the film cartridge, lower the rewind knob until it engages. You may have to turn the knob a little to one side or the other to make sure it is properly seated.

Pull out enough film leader to reach across the camera back to the takeup spool. Gently push the tip of the leader under one of the takeup spool tabs, until a sprocket hole in the film leader engages a small tooth on the tab. Do not push the leader in; do not let the leader show through the other side of the tab.

Alternately fire the shutter and stroke the camera's film advance lever until both the top and bottom sets of sprocket holes have engaged the film transport's sprocket teeth. Make sure the film is stretched flat across the back of the camera. If it is not, unfold the rewind crank and turn it gently in the direction of the arrow until the film is taut.

Close the camera back; fire the shutter and advance your film until the number 1 appears in the frame-counter window. A red bar will show in the Safe Load signal window to tell you that the film is advancing properly. Another way to check for proper film advance is to look at the rewind knob as you stroke the film advance. If the knob turns smoothly, the film is advancing as it should.

Rewinding. When you have made 12, 20, 24 or 36 exposures (depending on the length of your film), the advance lever will offer resistance. *Do not force it;* you will tear the film. Turn the camera upside down and press in the small rewind release button. Unfold the rewind crank and turn it in the direction of the arrow. As the film rewinds and reaches

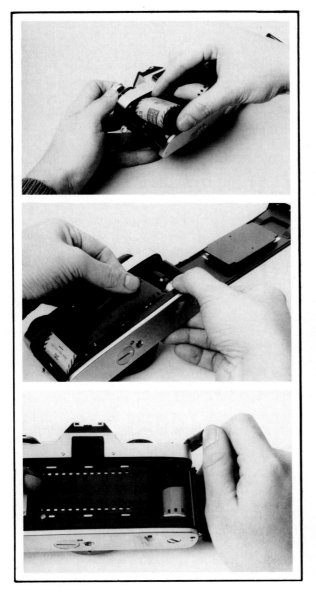

To load the camera, raise the rewind knob to open the camera back, and keep it raised while you position the film cartridge in the chamber below it.

When the cartridge is engaged, lower the rewind knob until it engages; then pull enough leader from the cartridge to reach the takeup spool and allow the sprocket holes in the film to engage in the spool's teeth.

Keep firing the shutter and advancing the film until both sets of sprocket holes have engaged the transport teeth of the takeup spool.

the point where the leader is connected to the takeup spool, you will feel some resistance. Keep turning the rewind knob until the resistance eases. Give one or two more turns to bring the leader into the cartridge, then lift the rewind knob to open the camera back and retrieve your film. The frame counter will automatically reset itself each time you open the camera back.

Changing Lenses

All of the cameras in Minolta's modern SLR system have the same lens-mounting controls. The bayonet mount used by Minolta is quick, extremely solid and reliable; lens changing is rapid and positive even in dim light, due both to the short turn required to mount and remove a lens, and to the oversized red mounting indices of the lenses and the lensmount flange on each camera body. To mount an MD or MC lens on your Minolta, follow the step-by-step guide below, or refer to your instruction manual. Various other components of the Minolta system, such as the Teleconverter 300S, 300L and the bellows units, have the same mounting system as the lenses, and are attached or removed in the same way.

A word of caution: *Always keep the front and rear lenscaps on your lenses when they are not in use.* The front lenscap will keep fingerprints, dust and the danger of scratches from interfering with the high image quality Minolta lenses can produce; the rear lenscap will protect

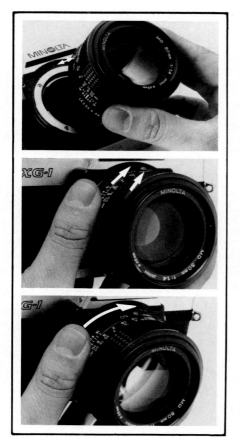

To mount a lens, hold the camera in your right hand and the lens (with rear lenscap removed) in your left, with the len's red aligning dot facing straight up.

Align the red dot on the lens with the red dot on the camera's lensmount flange, and insert the lens into the opening.

Turn the lens clockwise in about a one-fifth turn until you hear a click. The lens is now properly seated and locked in position.

the back element from the same dangers, and will prevent damage to the protruding auto diaphragm-coupling lever. If this lever is bent or otherwise damaged, the exposure system and meter will not be able to work properly. Be very careful not to rest the lens on its rear element without a lenscap in place.

Mounting a Lens. To mount a Minolta lens on your camera:

1. Hold the camera in your right hand, with its frontplate facing you.
2. Take the lens in your left hand (having first removed the rear lenscap by turning it counterclockwise and lifting it off) and hold it so that the large red aligning dot faces straight up.
3. Align the red aligning dot on the lens with the red dot on the camera's lensmount flange, and carefully insert your lens into the opening.
4. Turn the lens about one-fifth turn in a clockwise direction. You will hear a click, telling you that the lens is properly seated and locked in position.
5. Take off the front lenscap, attach a lenshood, and you are ready to shoot.

Removing a Lens. To remove a Minolta lens, hold the camera so the lens faces you and press in the small chromed lensmount locking button at the right side of the camera's lensmount. Holding the button down, turn the lens counterclockwise until its aligning dot is pointing upwards. Lift the lens away from the camera body.

To remove a lens, press in the small locking button next to the lensmount, and turn the lens counterclockwise until its red aligning dot points upward.

Body Cap. Just as the lenses need their front and rear elements protected, so does the inside of the camera. If you are not going to leave a lens on your Minolta SLR, attach a body cap to protect the mirror from damage and dust. The body cap can be attached and removed in the same manner as the lenses.

Mode/Exposure Control

The various automatic and manual exposure modes provided by the cameras in the Minolta system offer you a range of different ways with which to guarantee yourself the most accurate exposure possible. They also give you a great degree of control over the way your picture will look, without taking your concentration away from the subject.

Programmed Exposure Mode. Of all the automatic exposure systems available, the programmed automatic mode is the easiest to use. The camera's shutter speeds and lens openings are internally controlled by a tiny, computerlike device coupled to the light meter. Based on the film speed and the light reflecting from your subject, the camera will

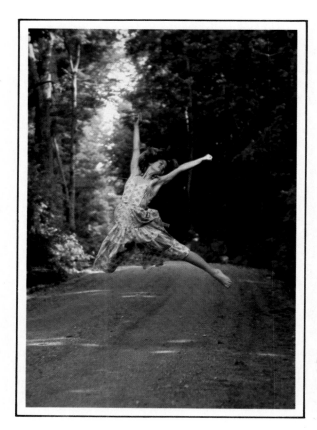

In situations where the action moves quickly from bright to shadowed areas, the programmed mode is an excellent adjunct to picturetaking. Because both shutter speed and aperture are selected for you, you need only follow the subject and fire the shutter at exactly the right moment. Photo: S. Szasz.

make all exposure decisions for you; all you need do is focus and press the shutter release. This system makes quick shooting, especially in fast-changing light, extremely simple.

Most programmed automation systems have one disadvantage: the exposure combinations are arranged to strike a compromise between moderate lens openings and shutter speeds. Under dim conditions, the shutter speeds provided sometimes are too slow for hand-held shooting.

Minolta has eliminated this drawback by designing a programmed exposure mode that gives emphasis to the shutter speed. Your chances of blurring a picture unintentionally are greatly reduced.

In order to give the programmed mode of cameras like the Minolta X-700 full control of your lens's apertures, you must set the lens to its smallest opening. On MD lenses, this aperture is marked in green. A lock is provided on newer MD lenses to make sure that they are not accidentally turned away from the minimum aperture. A green "P" will glow steadily in the X-700's finder to remind you that programmed automation is in use. If the "P" blinks intermittently, your lens is not set to its minimum aperture.

The programmed exposure mode will provide accurate exposures even if the lens is not set to its minimum aperture—but the camera's metering range will be limited. For example, if you accidentally leave your lens set at $f/5.6$, the fastest shutter speed/aperture combination the programmed mode will be able to supply will be 1/1000 sec. at $f/5.6$. If the lighting calls for less exposure than that, your picture will be overexposed. To avoid this, always make sure you have set the lens to its smallest opening.

Aperture-Priority Automatic Mode. This is the automatic exposure mode preferred by many professionals: the photographer chooses a lens opening, while the camera's automatic exposure system and light meter combine operations to set a shutter speed that will give a properly exposed photograph. Aperture-priority automation gives you full control over depth of field, since you, not the camera, decide on the aperture. You can also use the aperture control to shoot at specific shutter speeds, by turning the aperture ring until the automatic exposure system sets itself to the speed you are after.

Aperture-priority automation is completely electronic with Minolta SLRs. The shutter speeds are stepless, so that if the lighting conditions call for a shutter speed in between the standard speeds, the camera will provide it. Since the automatic exposure requires no special mechanical linkage with the aperture control, you can use aperture-priority automation with accessories such as bellows units, extension tubes and older, preset lenses. All currently made Minolta SLR cameras have aperture-priority automation as one of their exposure modes.

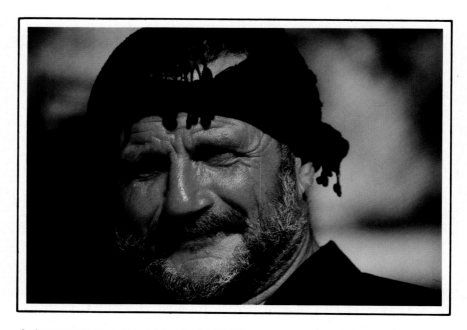

An important factor in determining depth of field is aperture size; the wider the aperture, the less depth of field, and vice versa. Here, a large aperture was used to throw the background out of focus. Manual or aperture-priority exposure is important here, because in a brightly lighted situation like this one, a fully programmed camera would probably choose a fairly small aperture. All the Minolta cameras offer one or several versions of aperture control. Photo: L. Jones

Manual and Metered Manual Exposure Modes. The Minolta X-700, X-570 and XG-1 all have manually controllable shutter speeds along with their automatic exposure modes. In the case of the X-700 and the X-570, the manual exposure settings are coupled to the light meter— you can see the meter's recommended exposure settings in the finder, and choose your shutter speeds accordingly; or you can ignore them altogether if you like. The XG-1 also lets you set your own shutter speeds, but without showing you the correct exposure. All three camera viewfinder displays will show a red "M" in the finder to warn you that you are in the manual mode and that the shutter speeds are no longer being controlled by the camera.

To use the X-700 and the X-570 as metered manual-exposure cameras, set the shutter speed you want to use, then turn the aperture ring until an LED lights up alongside the number representing the shutter speed you have chosen. If you want to shoot at a predetermined lens opening, set the aperture accordingly and then adjust the shutter-speed dial until its setting matches the one indicated in the viewfinder.

The same procedure can be followed with the XG-1, but you will first have to make your exposure readings with the camera set in its automatic mode. Make a mental note of the shutter speeds indicated, then turn the dial away from "A" to make your manual settings.

Two manually set shutter speeds are available on all Minolta SLRs: "X" and "B." The "X" setting provides the correct flash synchronization speed for Minolta's manual flash units and for those made by other manufacturers. If you have a Minolta Auto Electroflash, you can leave the camera set to an automatic mode—the flash unit's contacts will automatically set the correct synchronization speed.

The "B" setting is for exposure times longer than one second. With the camera set to "B," the shutter will stay open as long as the shutter release is depressed. A Minolta electronic remote release cord or cable release will let you use the "B" setting for exposures of any length beyond one second—for hours, if need be.

Use the "B" setting on your camera to make exposures longer than 1 sec. While long exposures generally require that the camera be supported by a tripod or other means, you can sometimes get excellent effects by deliberately jiggling the camera during the exposure, as a photographer did here while photographing city lights in Hong Kong harbor. Photo: D. E. Cox.

Shutter Speed Control

Your Minolta SLR, like most cameras of its type, has a *focal plane* shutter: a curtain-like device that passes a slit across the face of the film during exposure. The size of the slit and the speed with which it passes across the film determine how much light the film receives; the faster the curtain travels and the narrower the slit, the less light reaches the film, and vice-versa. In all currently made Minolta SLRs, the movement of the shutter curtain is controlled electronically. The batteries that supply power for the camera's light meter and exposure setting controls also drive the timing mechanism of the shutter.

When the camera is used in its automatic mode, the speed of the shutter is infinitely variable from its slowest to its fastest speed. Some models have slow speed limits of 1 sec.; others will automatically provide slow speeds of up to 4 sec. All Minolta cameras in the SLR system have a top shutter speed of 1/1000 sec.

If your Minolta has a manual exposure mode, you can set any one of a series of discrete speeds between 1 sec. and 1/1000 sec. The camera's shutter-speed dial is marked in a set of internationally agreed-upon fractions of a second, each providing approximately half as much light-passing power as the next slowest one, and twice as much as the next fastest. For the sake of convenience and legibility the speeds marked on the dial show only the bottom half of the fraction. The speed sequence used on modern cameras is 1; 2; 4; 8; 15; 30; 60; 125; 250; 500; 1000; meaning 1 sec., 1/2-sec., 1/4-sec., 1/8-sec., 1/15-sec., and so on. In addition to these speeds is a setting marked "B." With the dial set to "B," the shutter will stay open for as long as you hold the button down. There also may be a setting marked "X" on the dial. This indicates the speed necessary for proper shutter operation when you use electronic flash. The "X" speed for the shutters used in Minolta SLRs is 1/60 sec.; if you set a faster shutter speed than this for your electronic flash exposures, the shutter will not be completely open when the flash fires, causing part of the picture frame to be unexposed. Speeds lower than 1/60 sec. can be used, but might cause some blurring or "ghosting" of moving subjects if there is enough ambient light present.

Care and Feeding of Shutters. The electronically governed shutter mechanisms of modern, automatic SLRs like your Minolta are extremely reliable and accurate, having fewer mechanical parts to break down than mechanical shutter mechanisms have; still, it is a good idea to keep the shutter in good working order by firing it at all of its speeds from time to time. This is especially true of the slower speeds, which get less use than the moderate and fast ones used for most picturetaking. If you haven't used the camera for a couple of weeks or have not used the slow shutter speeds for some time, fire the shutter at each speed a couple of times before you load your next roll of film. Taking the camera in to be checked, cleaned and adjusted periodically will guarantee that the shutter stays in good working order.

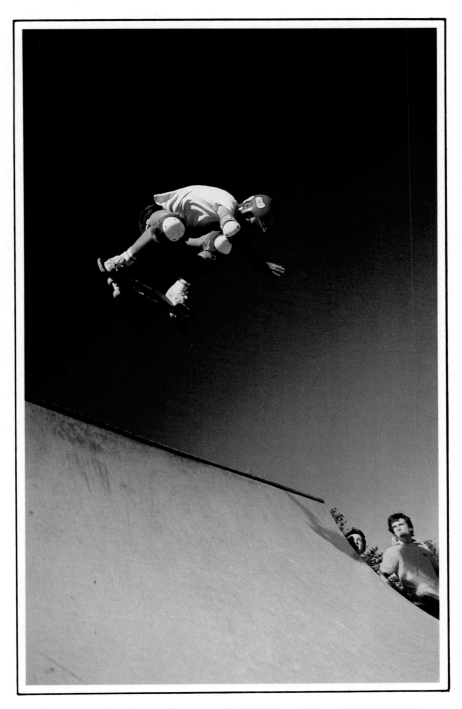

All Minolta cameras have a top shutter speed of 1/1000 sec., fast enough to freeze the movement of most rapidly moving subjects. The trick in capturing a subject like this is to know when the peak of the action will occur, and to release the shutter just before that peak. Photo: P. Eastway.

2

The Lenses

No part of your Minolta SLR affects the outcome of your pictures more than the lens does. The success or failure of your photograph depends at least as much on lens choice as it does on your exposure technique or choice of film.

Lenses make photographs possible by accepting light rays from objects in front of them, then "bending" these rays to form an image of their source on the film in the camera. The type of lens determines the type of image you get: standard or "normal" lenses give a lifelike, undistorted rendition, showing the subject much the same as it would appear to your unaided eyes. Wide-angle lenses include more subject area than your eyes take in at one glance. They exaggerate perspective in the process, making distant objects look smaller and near ones larger than they normally appear. Telephoto lenses narrow the angle of view while magnifying subject rendition. This lets you make pictures from an unobtrusive distance. It also lets you select and record specific details from the overall scene in front of you. Zoom lenses provide various angles of view in a single lens; with some zooms you can make wide-angle, normal and telephoto images from the same vantage point without stopping to change lenses. Macro lenses give extremely sharp results at very close focusing distances, letting you fill the frame with minute subject matter.

Perspective control lenses help you avoid the converging lines that occur as you aim your camera upwards to include the top of a building. Fisheye lenses give a 180-degree or wider view of the world; mirror-type telephoto lenses capture detail literally miles away. For those of you who photograph in poor light or at night without flash, there are lenses with enough light-collecting power to record extremely dim scenes.

Each of these lens types, along with others, is represented in the Minolta system.

Your choice of lens is one of the most important factors in the creative control of your image. Here, a 300mm lens was used to maintain a non-threatening distance from the tiny subject while at the same time making it appear fairly large in the frame. The photographer used a tripod to steady the camera during the 1/15-sec. exposure, made at f/16 for maximum depth of field possible with such a long lens. Even at small apertures, long lenses do not provide great depth of field. Photo: M. Fairchild.

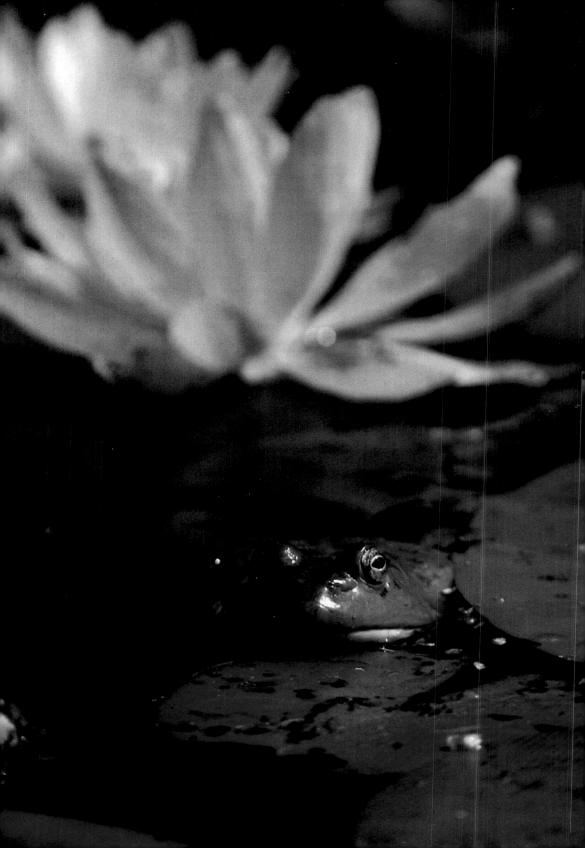

Lens Basics

Strictly speaking, a lens is any piece of transparent material with at least one of its surfaces curved so that it "bends," or refracts, light. A photographic lens is usually a *series* of glass or plastic lenses, arranged and spaced so that they can act together to produce an image of whatever is in their field of view. Each of these individual lenses is called an *element.* Any "lens" made up of two or more elements is technically called a *compound* lens; but since all modern photographic lenses are compound, the word is dropped from general discussion.

Each lens has a specific *focal length.* The focal length has little to do with the physical dimensions of the lens; it is a measurement made from the optical center of a lens to the camera's film plane, with the lens focused on a distant object (infinity). Focal length is the most important characteristic of a lens, since it determines more than any other factor what kind of picture the lens can produce.

Focal length controls *image size,* determining how large your subject will appear in the frame from any given shooting distance. It also governs the *angle of view,* or amount of subject area that can be recorded at any camera-to-subject distance.

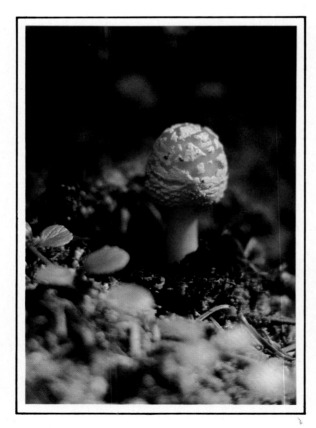

Photographed with a short telephoto lens and an extension tube, this tiny mushroom takes up a good part of the frame. The shallow depth of field typical of telephoto lenses is made shallower by the use of the tube — a useful effect when you want to separate a small subject from a distracting background. Photo: M. Fairchild.

Wide-angle lenses encompass a large field of view and are generally characterized by great depth of field — almost everything in the photograph is in sharp focus. Some distortion of parallel lines may also occur with these lenses. Photo: M. Haven.

As the focal length increases, image size becomes larger, while the field of view is narrowed. The shorter the focal length, the smaller the image size, with a correspondingly wider field of view. Long-focal-length lenses allow you to fill your viewfinder with subjects that are too small or too far away to appear large from your shooting position; short focal lengths expand your scene rendition, letting you encompass large areas without moving back.

How long is long, and how short is short? One easy way to decide is to take a look at how the lenses in the human eye see things. As you look straight ahead, each of your eyes normally takes in an angle of view of about 47 degrees. Because of this, lenses that provide a similar angle of view will make subjects appear similarly to the way the eye sees them. These lenses are referred to as "standard" or "normal" lenses. In 35mm photography, normal lenses have focal lengths ranging from about 45mm to 60mm or so, depending on their design and maker.

Lenses of 35mm and shorter are called *wide angle,* because of their expanded field of view; those with focal lengths above 60mm are called, depending on their optical construction *long focus* or *telephoto.* Long focus lenses are physically as long as their focal length. Telephotos are designed to be physically shorter than their focal length. At one time, the complexity of building telephotos made them more expensive and more prone to optical defects than were equivalent long-focal-length types; but the use of new glasses, computer-assisted design and multiple lens coatings has given us light, small telephotos with outstanding image quality. All of the longer-than-normal lenses in your Minolta system are of the easier-to-handle, more compact telephoto type.

Focal Length and Apparent Perspective. Shooting from the same camera-to-subject distance with different focal lengths will give you control over image size and angle of view, but will not affect perspective. For example, if you were to photograph the same subject from the same shooting distance, first with a 135mm lens and then with a 50mm lens, and then enlarged the 50mm picture so that your main subject would appear the same size as it did in the 135mm photograph, you would see that the relative size and distance of various objects in the frame would appear the same in both photographs. It makes no difference which focal lengths you do this with; as long as you make the pictures from the same distance, perspective rendition will be the

The photograph above left was taken with a 135mm lens; the one above right with a 50mm lens. At left, the main subject of the 50mm photograph has been enlarged to the same size as that of the 135mm photograph. The relative size and distance of all objects in the frame appear the same in the 135mm photograph and in the 50mm enlargement. Photo: B. Sastre.

same. But if you moved closer or further away from your main subject, using different lenses to keep his or her image size the same as you looked through the camera's viewfinder, you would notice a radical change in the relative size of near and far objects.

For any given image size, short focal lengths will exaggerate perspective more than longer ones, making near objects look larger and far objects smaller than they appear normally. The shorter the focal length, the more noticeable the apparent distortion. Longer than normal focal lengths used under the same conditions will compress perspective rendition, making near and far objects look closer together and closer in size. A look at the series of pictures on these pages will give you an idea of how variations in perspective can be used to control the final outcome of your photographs.

Lens Apertures and "Speed." The word "aperture" means opening, and it is the aperture of a lens that determines how much light is allowed to pass through it onto the film. Apertures are controlled by a multibladed device called an *iris diaphragm,* located near the optical center of most lenses. The diaphragm is set by means of a click-stopped ring on the lens barrel, marked in *f-numbers.* F-numbers, or f-stops, are arranged so that each passes either twice or half the amount of light as the one next to it. As the numbers get higher, the amount of light allowed through the lens decreases, and vice-versa. The numbers of all modern lenses are standardized in the following sequence: $f/1$; $f/1.4$; $f/2$; $f/2.8$; $f/4$; $f/5.6$; $f/8$; $f/11$; $f/16$; $f/22$; $f/32$ and so on. Each number will pass one stop more, or twice, the amount of light as the next largest number, and one stop less, or half, the light of the next smallest f-number in the progression.

F-numbers indicate the *relative* light-passing power of a lens, no matter what focal length it happens to be. For example, $f/4$ on a 100mm lens will pass the same amount of light as $f/4$ on a 20mm lens, even though the physical diameter of its lens opening will be bigger.

The *maximum aperture* of a lens is the largest opening it has. Lenses are usually referred to by their focal length along with their maximum aperture. In many cases, the maximum aperture does not correspond with the standard f-numbers. A 105mm $f/2.5$ lens will pass more light at its maximum aperture than an $f/2.8$ lens would, but not as much as an $f/2$ lens. Designers make some lenses with intermediate maximum f-numbers so that photographers can have as much light-passing power as they can get without degrading image quality.

The more light-passing power a lens can give at its maximum aperture, the *faster* the lens is said to be. Generally speaking, lenses with maximum apertures of $f/2$ or larger (meaning lower f-numbers) are considered "high speed" or fast lenses. Fast lenses are essential to photographers who have to work in dim conditions without artificial lighting; they are also useful when long, heavy lenses have to be used without a tripod: the large maximum aperture allows the use of fast shutter speeds, which help avoid camera shake.

Depth of Field

Most photographic subjects are three-dimensional; unless you are making a photographic copy of an extremely flat object lying absolutely parallel to the film plane, your subject has depth, as well as breadth and height. Photographs have no physical depth—they are two-dimensional interpretations of a three-dimensional reality.

This means that theoretically, at least, you can only get one very small portion of your subject in focus at any one time. Practically speaking, however, there is always some area in front of and behind the area you have focused on that appears sharp as you look at your image.

This acceptably sharp zone is called *depth of field*. How much depth of field there is depends on several factors: the image size provided by the lens you are using; the distance from your film plane to the area you have focused on; and the aperture in use.

Because of the way in which different focal length lenses bend light, shorter focal lengths will give more depth of field than longer ones, at any given aperture and focusing distance. As you change the camera-to-subject distance, depth of field will also change: the closer you get to your subject the less depth of field you will have, with any focal length, at any given lens opening. With any given focal length lens, at any given focusing distance, smaller lens openings will give you more depth of field than larger ones. Finally, depth of field always extends further behind the point you have focused on than in front—with any lens, at any aperture and focusing distance.

Depth of field refers to the area in a picture that is in sharp focus. In this photo, the depth of field is considerable; all elements but those at the very bottom of the frame are completely sharp. Small lens openings, which are more frequently possible with stationary subjects, give greater depth of field than large lens openings. Photo: D.E. Cox.

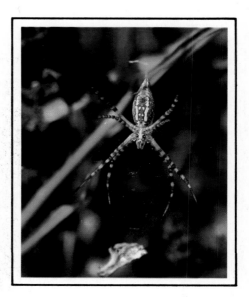

The closer you get to your subject, with any lens at any given aperture, the less depth of field you have. With close-up photography, the depth of field will invariably be quite shallow. Note here that the portion of each of the spider's legs farthest away from the body (the main point of focus) is to some degree out of focus. Photo: M. & C. Werner.

What all of these laws of optics amount to is that you will get the greatest depth of field with an extremely wide-angle lense used at its smallest opening to make pictures of faraway objects, and the least depth of field with a very long telephoto at its widest aperture and closest focusing distance. Neither situation occurs too frequently for most photographers; but even under more moderate shooting conditions, the depth of field in your pictures has a tremendous impact on their success or failure. For example, if your subject is constantly moving, use the smallest aperture you can get away with, just in case it moves beyond the point you have focused on by the time you release the shutter. The added depth of field will help ensure a sharp rendition of your subject (provided, of course, that your shutter speed is still fast enough to freeze the motion). If, on the other hand, you want to eliminate distracting background information in a portrait, use a telephoto lens at a wide aperture to limit the depth of field to your subject's features.

The shallow depth of field given by telephoto lenses may sometimes not be enough to render all of a subject's features sharply. Fortunately, lenses usually have a depth of field scale built into their barrels. The scale has a series of *f*-stop markings on either side of the focusing index of the lens. These aperture markings align with the lens distance scale (usually given in both meters and feet) to show you where the near and far limits of acceptable sharpness are at each *f*-stop. Keep your eye on the depth of field scale, especially when you use long lenses at close focusing distances. It will help you choose a small enough opening to avoid such dismay-producing mistakes as portraits with the subject's ears out of focus, or cityscapes with disturbingly fuzzy foregrounds.

Normal Lenses

Like most Minolta SLR users, you probably bought your camera with a 45mm or 50mm "normal" lens. Lenses of this focal length take in an angle of view quite similar to that seen by each eye as it looks straight ahead—47 degrees or so—hence the word "normal." This angle of view gives a pleasant, undistorted-looking perspective rendition; the world as seen through a normal lens looks much the same as it does without the help of your camera.

Because of its ability to provide natural-looking views of the subject, the normal lens has long been a favorite of photographic artists and photojournalists. More work done with normal lenses appears in newspapers, magazines and on gallery and museum walls than that done with any other lens type. The normal lens, used creatively, is a virtual window on the world.

The normal lens is prized by photographers for its ability to give undistorted, natural-looking perspective with an angle of view similar to that seen by the human eye. Because it does not give bizarre effects or perform tricks with distance and image size, the normal lens presents a special challenge to the photographer's creativity. Foreshortening of the subject by use of an unexpected high angle adds drama to the image. Photo: L. Jones.

Compared to other lens types, normal lenses are usually lighter, more compact, and faster, with excellent sharpness and handling characteristics. Normal lenses are among the most versatile optical tools at your disposal. They lend themselves equally well to nature studies, landscapes, impromptu portraiture, "street" pictures and a host of other general picturetaking situations.

This does not mean that a normal lens will give you the answer to *every* photographic problem you might encounter. There will be times when you need appreciably wider or narrower coverage than a normal lens can provide. Still, a surprising number of photographers waste valuable picturemaking seconds by changing to a wide-angle or telephoto when they would be better off keeping the normal lens on their cameras and stepping backward or forward a few paces to change the amount of subject area included in their camera's viewfinder.

SPECIFICATIONS: MINOLTA NORMAL LENSES

Lens	Angle of View	Minimum Focus	Minimum f-Stop	Filter Thread Diameter
50mm f/2 MD	47°	0.45m (1.5 ft)	f/22	49mm
50mm f/1.7 MD	47°	0.45m (1.5 ft)	f/22	49mm
50mm f/1.4 MD	47°	0.45m (1.5 ft)	f/16	49mm
50mm f/1.2 MD	47°	0.45m (1.5 ft)	f/16	55mm

Try this for yourself: if you are unhappy with the way your subject looks through the normal lens, move back a step or two to give the subject more "breathing room"; or, if the main subject seems to be getting lost in its surroundings, move forward to make it appear more prominent. More often than not, you will find the scene improving as you move. When everything looks "in place," make your exposure. All of this takes far less time than you would think—usually one step closer or farther away will be enough to improve the visual rendition of your scene. With a little practice, you will find yourself able to keep focusing as you move, so you will be ready to expose the instant the scene looks right.

Wide-Angle Lenses

Wide-angle lenses—those with focal lengths shorter than 40mm or so —let you take in more subject area than you can with normal or longer-than-normal focal lengths. They also give a smaller-than-normal image size at any given focusing distance. This makes them somewhat more challenging to use for general picturemaking than are normal or telephoto lenses; but used carefully and under the right circumstances, wide-angle lenses will give you striking and unique views of your subjects.

Perspective. Wide-angle lenses exaggerate perspective rendition. Through a wide-angle lens, objects very near your camera seem to reach out of the viewfinder (and your pictures); those in the background appear to be further away and smaller than they would to your normal lens or unaided eye. The more "wide" the lens (that is, the shorter its focal length), the more exaggerated the perspective seems.

The closer to normal (45mm or 50mm) the focal length of a wide-angle lens, the less exaggerated its perspective rendition. Because of this, moderate wide-angle lenses in the 35mm to 28mm range are used

Wide-angle lenses may be used to add a wonderful sense of distortion to a scene. However, strange effects like this one must be used with discretion; not all subjects lend themselves to successful manipulation. Photo: J. Isaac.

extensively by press photographers, wedding photographers and people who make travel and landscape pictures. Moderate wide-angle lenses will give you appreciably greater-than-normal subject coverage without altering the natural look of the scene too much. Many photographers have adopted the 35mm lens as an "alternate-normal" focal length. Others, especially those who do much of their work indoors or make pictures of large groups of people, find the 28mm lens extremely useful. Its perspective rendition is somewhat more extended than that given by 35mm or 50mm lenses, but not enough to give most photographs an artificial appearance.

All wide-angle lenses give greater-than-normal depth of field at any given aperture. The shorter the focal length, the more depth of field. The 28mm focal length is ideal for photography of fast-moving subjects or changeable situations, where stopping to focus with care might cause you to miss the picture. For example, a 28mm lens, focused at 3m (10 ft) and set to $f/8$ will render sharply everything from 1.5m (5 ft) away to infinity; at the same distance and aperture, a 50mm lens will give sharp results in a far narrower range: from about 2.3 to 4.2m ($7^3/_4$ to 14 ft).

Environmental portraits showing how a person lives or works are often best done with a moderate wide-angle lens in the 35mm to 28mm range. Such a lens will provide a good portrait of the sitter without too much distortion, plus a wide enough angle of view to encompass his or her immediate setting. Photo: M. Haven.

The extra depth of field given by wide-angle lenses is a definite asset, but it has its price; all wide-angle lenses exhibit a certain amount of distortion. The distortion is most obvious with extremely wide-angle lenses, especially when the scene contains vertical lines or round objects near the edges of the frame. Straight vertical lines might appear to curve outward toward the edges of the picture; circular and spherical subjects might look pulled out of shape and egglike. This distortion can be used to add a certain dynamic quality to many photographs; but to keep it to a minimum under normal circumstances, keep the camera *absolutely* level. The slightest tilt will make the lens distort more.

SPECIFICATIONS: MINOLTA WIDE-ANGLE LENSES

Lens	Angle of View	Minimum Focus	Minimum f-Stop	Filter Thread Diameter
28mm f/3.5 MD	75°	0.3m (1 ft)	f/22	49mm
28mm f/2.8 MD	75°	0.3m (1 ft)	f/22	49mm
28mm f/2 MD	75°	0.3m (1 ft)	f/22	55mm
35mm f/2.8 MD	63°	0.3m (1 ft)	f/22	49mm
35mm f/1.8 MD	63°	0.3m (1 ft)	f/22	49mm

The Ultra-Wides. Lenses with focal lengths shorter than 28mm are considered ultra-wide-angle optics. They provide tremendous depth of field even at their widest apertures, and exaggerate perspective so much that they are difficult to use for general picturetaking. However, ultra-wide-angle lenses are powerful tools in the hands of creative pictorial, commercial and architectural photographers. Lenses of 24mm and 20mm are used to provide palatial-looking renditions of studio apartment interiors, or to make modest front yards look like vast lawns; shorter focal lengths will give sandlots the appearance of deserts. Buildings and people just across the street can be made to seem miles away. With a little imagination and practice, ultra-wide-angle lenses will let you record the most ordinary subjects in a dreamlike, surreal fashion.

Unless you are interested in photographic caricature, extremely wide angle lenses should not be used for portraiture. Their perspective distortion is so great that facial features will be exaggerated to ridiculous extremes; extended noses, hands and feet might become bigger than your subject's head or torso. To avoid this distortion, you would have to stand far enough away to make your subject so tiny as to be all but invisible in the final picture.

Ultra-wide-angle lenses, when used appropriately, can provide stunning visual effects. Here, a 24mm f/2.8 lens was used to make a brilliantly dramatic image in an escalator shaft. Photo: D.E. Cox.

Extremely wide angle lenses are difficult to focus properly, especially in poor light. Their tremendous depth of field makes it very hard to determine just when your subject is in pinpoint focus, since in many cases everything will look sharp. For critical work, use the rangefinder wedge built into the focusing screen of your Minolta. In any event, ultra-wide-angle lenses have so much depth of field that under normal conditions, focusing becomes all but superfluous. Keeping the camera level, on the other hand, is absolutely essential with ultra-wide-angle lenses. The slightest tilt of the camera will give you massive distortion. To avoid this, use a tripod; if possible, get one with a built-in bubble level, which will help you determine whether the tripod is as level as you can get it. If you already own a tripod without a bubble level, look for a small level that you can attach to your camera's accessory shoe.

SPECIFICATIONS: MINOLTA SUPER-WIDE-ANGLE LENSES

Lens	Angle of View	Minimum Focus	Minimum f-Stop	Filter Thread Diameter
17mm f/4 MD	104°	0.25m (0.8 ft)	f/22	72mm
20mm f/2.8 MD	94°	0.25m (0.8 ft)	f/22	55mm
24mm f/2.8 MD	84°	0.3m (1 ft)	f/22	55mm

Telephoto Lenses

Most photographers choose a telephoto lens as the first addition to their optical arsenal. Telephoto lenses magnify image size and narrow the angle of view, as compared to normal lenses. These two attributes combine to let you fill the frame better with important areas of your scenes from a comfortable distance. Telephotos give less depth of field at any given apertures than do normal lenses; this makes them ideal for emphasizing your main subject by subduing the sharp rendition of busy or inappropriate backgrounds. These longer-than-normal lenses also compress perspective, making distant objects appear closer than they would to the naked eye.

Moderate telephoto lenses are useful for photographing shy or potentially dangerous wildlife from safe distances. By moving in closer, it is possible to make photographs that give no indication of whether they were made in the wild or at a zoo. This effect is assisted by the relatively shallow depth of field of these lenses which helps eliminate background detail. Photo: M. & C. Werner.

Short telephoto lenses are ideal for photographing street scenes and children at play without becoming too intrusive. In some instances, these lenses will also keep the photographer at a safe distance from any potentially damaging activity. Photo: D. E. Cox.

Short Telephotos. Just how much a telephoto will increase image size, narrow the angle of view and depth of field and compress apparent perspective depends on its focal length. Short telephotos, ranging from 85mm to 150mm or so, are best suited to most general photographic subjects because they provide up to three times the image size of a normal lens while remaining relatively compact and easy to hand-hold. Lenses of 85mm and 100mm are perfect for full-face or head-and-shoulder portraits; their slightly compressed perspective helps you avoid the facial distortion you would get if you tried these kinds of portrait with your normal lens. The 135mm lens is a favorite with travelers and many pictorial photographers, since it gives about 2½ times the "reach" of a normal lens, yet has a close enough focusing distance to let you make frame-filling pictures of flowers and small animals. The 135mm focal length will let you shoot children at play or scenes of street life without being noticed, so you can preserve the candid appearance of your subjects.

Short telephoto lenses have relatively large apertures, usually in the $f/2$–$f/3.5$ range. This makes them useful for picturemaking in low light without the need for flash. Some 85mm lenses have maximum apertures as large as $f/1.8$; informal portraits, stage performances and night scenes are easy to make with this lens type and some fast film.

Moderate Telephotos. Moderate telephotos, with focal lengths from 150mm to 200mm, are used extensively by fashion photographers and other professionals. Their marked apparent perspective compression and shallow depth of field all but eliminate distracting background detail when used at their larger apertures and close focusing distances. Background colors can be made to assume the role of a field against which to set off the main subject or model. If you are interested in photographing sports action or wildlife, moderate telephotos will let you reach into the game from the sidelines, or photograph less-than-friendly animals from a safe distance. The 200mm lens is used by some photographers to produce zoo pictures that look as though they were shot in the wild; the image magnification of these lenses will let you shoot right through the bars or beyond obstacles that might give away the fact that the pictures were made in a zoo.

Long Telephotos. Long telephoto lenses, ranging from 300mm upwards, are (understandably) heavy, unwieldy and expensive. These special tools are of little use in general photography, but their tremendous apparent perspective compression, extremely narrow angle of view and great image magnification can be used to make pictures of virtually inaccessible objects. Sports photographers use these lenses to

Long telephoto lenses are especially popular with sports photographers, who need to get very close to the action without actually becoming a part of it. Such lenses can rarely by used without a sturdy tripod or other support, since even slight camera shake will cause the image to become unacceptably blurred. Photo: P. Bereswill .

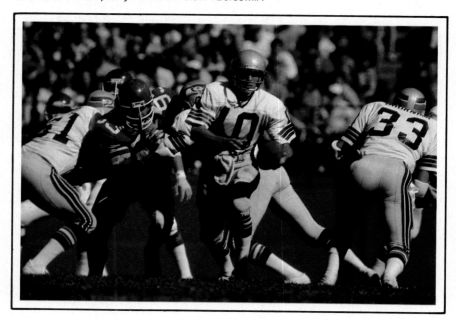

pick out facial expressions from hundreds of meters away; surveillance photographers find them extremely useful, as do those interested in graphic depictions of skylines and other faraway objects.

Telephoto lenses, especially the longer ones, are not very forgiving of exposure errors. The shallow depth of field they exhibit makes accurate focusing essential. Luckily, the image snaps in and out of focus easily with most telephoto lenses, so careful focusing is not difficult.

SPECIFICATIONS: MINOLTA SHORT AND MODERATE TELEPHOTO LENSES

Lens	Angle of View	Minimum Focus	Minimum f-Stop	Filter Thread Diameter
85mm f/2 MD	29°	0.85mm (2.8 ft)	f/22	49mm
85mm f/1.7 MD	29°	1.0m (3.3 ft)	f/22	55mm
100mm f/2.5 MD	24°	1.0m (3.3 ft)	f/22	55mm
135mm f/3.5 MD	18°	1.5m (4.9 ft)	f/22	49mm
135mm f/2.8 MD	18°	1.5m (4.9 ft)	f/22	55mm
200mm f/4 MD	12°30'	2.5m (8.2 ft)	f/32	55mm
200mm f/2.8 MD	12°30'	1.8m (6 ft)	f/32	72mm

SPECIFICATIONS: MINOLTA LONG TELEPHOTO LENSES

Lens	Angle of View	Minimum Focus	Minimum f-Stop	Filter Thread Diameter
300mm f/5.6 MD	8°10'	4.5m (14.8 ft)	f/32	55mm
300mm f/4.5 MD	8°10'	3.0m (9.8 ft)	f/32	72mm
400mm f/5.6 MD APO*	6°10'	5.0m (16.4 ft)	f/32	72mm
600mm f/6.3 MD APO*	4°10'	5.0m (16.4 ft)	f/32	integral lens-element type

*The letters APO stand for "apochromatic," to indicate that the lens has been specially designed to virtually eliminate chromatic (color) aberrations.

Camera shake is also a problem when you shoot with a telephoto lens. As a rule of thumb, never hand-hold any lens that is too long to hold comfortably; and never shoot at shutter speeds slower than 1/ the lens's focal length. For example, a 200mm lens should never be used without a tripod at speeds slower than 1/200 or 1/250 sec., or chances are that your picture will be blurred. If the day is especially windy or you are less than rock steady, keep your minimum hand-held speed no slower than 1/twice the focal length (for example, at 1/500 sec. with a 200mm lens).

Extremely long lenses should always be used with a sturdy tripod —and a cable release, to further reduce the chances of camera shake. If you find yourself in a situation where you must shoot hand-held, always support the lens with your hand: the lens will be heavier than your camera, so that is where the support is needed.

This type of photograph can only be made with a zoom lens. The camera is mounted on a tripod and the lens is steadily zoomed in or out across the focal range. Exposure must be calculated carefully; 1 sec. is about right for a 2:1 zoom range, but must be longer for a lens with a longer zoom range. Photo: T. Tracy.

Zoom Lenses

If you have ever missed a picture because the scene changed or your subject disappeared while you took time to change lenses, or if you often feel weighed down enough by the handful of lenses in your camera bag to get less than eager about walking around and making pictures, the zoom lens may be just what you are looking for.

Although zoom lenses have been in common use by cinematographers for some time it is only recently that still-camera zooms have begun to attain any popularity. Until just a few years ago, those zoom lenses that were available were expensive, heavy, unwieldy and not nearly as sharp as the single-focal-length lenses they were meant to replace. Early still-camera zooms were considered playthings for the rich photographer who was not overly concerned with image quality.

No more. Modern zooms are remarkably light, compact and affordable, providing their users with image quality as good as that obtainable from any other lens type. Zooms are fast becoming the most popular lenses of all, among amateurs and professionals alike.

How Zooms Work. Lenses that "zoom" do so via a special cam which alters the relative placement of their various element groupings. Repositioning the groupings produces different focal lengths. The zooming cam is connected to a control on the lens barrel, letting you alter the focal length easily without taking the camera away from your eye.

One touch zooms have a combined focusing/zooming collar; you turn the collar clockwise or counterclockwise to focus, and move it back and forth to change the focal length setting. *Two touch* zooms have a conventional focusing collar with a separate zooming ring placed just behind it. All other things being equal, one-touch zooms are slightly faster to use, while those of the two-touch variety allow you to zoom without risking a slight accidental change of focus. In practice, however, both zooming systems are equally accurate and easy to use; the lens designers build in whichever system allows the lens to be as compact and efficient as possible.

Minolta's 24–50mm zoom (left) is of the two-touch variety, having a conventional focusing collar (A) as well as a separate zooming ring (B). The 50-135mm lens (right) is a one-touch zoom, operated by a combined focusing/zooming collar (C).

General-Purpose Zooms. Since most photographs are made with lenses ranging in focal length from slightly shorter to slightly longer than normal, the most useful general-purpose zoom ought to cover the same range, while being compact enough to allow easy hand-held shooting. A 35–70mm zoom covers this most popular range, letting you make scenics and establishing shots at its shortest setting, and head-and-shoulders portraits at its longest, with infinitely variable focal length settings in between. Many photographers find that a zoom in this range is the only lens they ever need, except for those instances when the light is extremely low. General-purpose zooms usually have a maximum aperture of about $f/3.5$—enough for the majority of daylight and flash pictures. One of these lenses, along with a normal lens of $f/2$ or faster, makes a perfect combination for vacation photography. Keep the zoom on your camera for most of your pictures, and the faster normal lens available for pictures taken at dusk or any time when you want to preserve the natural mood of a dimly lighted scene.

If you are willing to carry around a little extra weight and add somewhat to the overall length of your zoom, you can increase your photographic range considerably. Macro-focusing zooms such as a 35–105mm $f/4.5$ lens give greater selection of focal lengths and closer focusing capability that allow, at their closest focusing distance, one-quarter-lifesize renditions of the subject. These "extended range general-purpose" zooms are especially useful for closeups of flowers, insects and other small subjects, as well as for general scenes.

This combination of two zoom lenses might well cover all your photographic needs. Minolta's 35-105 macro-focusing zoom will give you "wide-normal" to moderate telephoto coverage, plus macro capabilities; the 100 – 200mm zoom will provide for most other handheld telephoto needs.

Normal-to-moderate telephoto zooms allow you to make excellent candid portraits without being obtrusive. For this reason, and because they are relatively light in weight, they are ideal for travel photographers.
Photo: J. Isaac.

Normal-to-Moderate Telephoto Zooms. Normal-to-moderate tele-photo zooms, ranging from 50–135mm, are designed with the portrait and candid photographer in mind. They will let you make full-figure portraits and head shots of average-height subjects from about 2.5m (8 ft) away. These zooms are also ideal for photographing people at work or play without your getting close enough to disturb them or to interfere with the natural flow of events.

Wide-Angle Zooms. If you are mainly interested in scenics, land-scapes or photographs of groups and want to avoid having to carry a series of wide-angle lenses with you, a zoom with a focal length range from about 24mm to normal would fit your purposes best. These wide-to-normal zooms are well suited to photography in cramped quarters as well. They are regular working tools of many photojournalists. The large angle of view given at 24mm allows full coverage of conferences, meetings and fast-breaking events; at the other extreme, the wide-to-normal zoom gives the 50mm length's normal-looking perspective ren-dition. A 24–50mm zoom, along with one ranging from 50mm to about 135mm, might form the basis of a complete one-camera/two-lens sys-tem for many photographers. With your camera, these lenses and an electronic flash unit in a small gadget bag, you will have all of the equipment you need to handle virtually any picturetaking situation you might encounter.

Short- to Medium-Telephoto Zooms. If you like the idea of being able to fill your frame with subject matter from across the street, or are intrigued by the compressed perspective rendition given by telephoto lenses, a zoom ranging from slightly longer than normal to about 200mm would be ideal, providing a substantial amount of optical "reach" without being too large and heavy to carry and use comfortably. Short- to medium-telephoto zooms are among the most popular of all, giving the coverage needed for portraiture, travel pictures, sports, nature photography and pictures of architectural detail. At their longest focal length, they provide a flattening of apparent perspective that gives certain subjects heightened graphic appeal.

Zooming to the Limit. Extremely long zooms, ranging from moderate telephoto to about 500mm are understandably large, heavy and expensive. These specialized items are too cumbersome for general photography, but indispensable to sports photographers and those who make pictures of dangerous animals. A focal length range from 100–500mm allows the sports photographer at the sidelines of a football game to

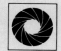

Technique Tip: Getting the Most Out of Your Zoom

- Zooms are complex optical instruments, sometimes having more than a dozen elements. Even with multiple coating and carefully baffled interiors, zooms are more prone to flare than many single-focal-length lenses are; *always* use the appropriate lens shade with your zoom, to assure yourself of the sharpest, most contrasty image rendition the lens is capable of.
- For absolute sharpness hand-held, determine the lowest allowable shutter speed by the longest focal length available on your zoom. Unless you want to run the risk of blurring the picture, use a tripod or other support for any shutter speed slower than 1/ the longest focal length, or the closest speed to it: with a 70–150mm zoom, for example, keep your hand-held speed above 1/125 sec.; with a 24–50mm zoom, be very careful if the shutter speed is below 1/60 sec., and so on.
- If your zoom is of the one-touch variety, be careful not to move the zooming control from side to side as you change focal lengths, or you will have to refocus.
- With both one-touch and two-touch zooms, focus at the longest zoom setting, then zoom to the focal length you need for your picture. Focusing is always easier at the longest lengths, especially with wide-to-normal zooms.

record the huddle; a closeup of the quarterback ready to pass; and the receiver wrapping his fingers around the ball—all from the same shooting position, simply by following the action and sliding the zoom control back and forth at the appropriate moment. You may never need to use a zoom this long, unless sports or animals make up the majority of your subjects; but the Sunday morning sports page and your wildlife magazine would not be the same without them.

Using a Zoom to Improve Composition. Besides providing a variety of focal lengths in one compact package, zoom lenses have another tremendous advantage over single focal lengths: their continuously variable focal lengths allow you to make slight adjustments in coverage, not so much for added width or reach as for fine-tuning the arrangement of your subject matter in the frame. Zoom lenses allow you the luxury of "cropping in the camera" without having to move from your vantage point. It is much faster to move the zoom control slightly in order to eliminate unwanted objects at the edges of the viewfinder than it is to do the same thing by moving forward. Zoom lenses give you the option of shooting at focal lengths in between those available with single-focal-length lenses. If your picture seems to work best at, say, 77mm, a zoom whose lens covers that length will give it to you; moving back or forward with a longer or shorter single-focal-length lens will never give you exactly the same rendition of apparent perspective, even if you get to the right distance in time to make the exposure before the scene changes.

SPECIFICATIONS: MINOLTA ZOOM LENSES

Lens	Angle of View	Minimum Focus	Minimum f-Stop	Filter Thread Diameter
24–35mm f/3.5 MD	84°–63°	0.3m (1 ft)	f/22	55mm
24–50mm f/4 MD	84°–47°	0.7m (2.3 ft)	f/22	72mm
28–85mm f/3.5 MD*	75°–29°	0.8m (2.6 ft)	f/22	55mm
35–70mm f/3.5 MD**	63°–34°	0.8m (2.6 ft)	f/22	55mm
35–105mm f/3.5 MD†	63°–23°20'	1.5m (4.9 ft)	f/22	55mm
50–135mm f/3.5 MD	47°–18°	1.5m (4.9 ft)	f/32	55mm
70–210mm f/4 MD	34°–12°	1.1m (3.6 ft)	f/32	55mm
75–150mm f/4 MD	32°–16°30'	1.2m (3.9 ft)	f/32	49mm
75–200mm f/4.5 MD	32°–12°30'	1.2m (3.9 ft)	f/22	55mm
100–200mm f/5.6 MD	24°–12°30'	2.5m (8.2 ft)	f/22	55mm
100–300mm f/5.6 MD	24°–8°10'	1.5m (4.9 ft)	f/32	55mm
100–500mm f/8 MD APO‡	24°–5°	2.5m (8.2 ft)	f/32	72mm
100–500mm f/8 MD	24°–5°	2.5m (8.2 ft)	f/32	72mm

*In macro range, minimum focus is 0.25m (0.8 ft).
**In macro range, minimum focus is 0.33m (1.08 ft).
†In macro range, minumum focus is 0.41m (1.3 ft).
‡The letters APO stand for "apochromatic," to indicate that the lens has been specially designed to virtually eliminate chromatic (color) aberrations.

Macro Lenses

Most photographic lenses are designed to produce their best results at far focusing distances; their sharpness falls off slightly when used extremely close to the subject. *Macro* lenses, however, are computed to give excellent resolution at their closer focusing distances. They are also capable of superb results when used under less intimate circumstances.

Macro lenses should really be called macrofocusing lenses, since they are designed to let you photograph small objects up to lifesize (usually with an extension-tube-like adapter). They have focusing helicals that let you get as close as necessary to produce a half-lifesize view of your small subject. Macro lenses of 50mm have close-focusing distances of about 22cm (9 in); 100mm macros will bring you as close as 0.45m (1½ ft) or so. The latter focal length is especially useful for photographing insects and other skittish creatures that might get frightened away if you move in too close for their comfort.

Macro lenses are designed to produce a half-lifesize view of a very small subject. To produce a lifesize (1:1) view, an adapter may be used between the camera and the lens. Shown here is the Minolta 100mm f/4 macro lens with a lifesize adapter. The adapter mounts between the camera and the lens.

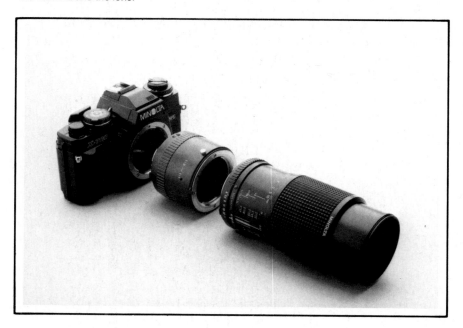

SPECIFICATIONS: MINOLTA MACRO/BELLOWS LENSES

Lens	Angle of View	Minimum Focus	Minimum f-Stop	Filter Thread Diameter
50mm f/3.5 MD Macro	47°	0.23m (9 in)	f/22	55mm
100mm f/4 MD Macro	24°	0.45m (1.5 ft)	f/32	55mm
12.5mm f/2 Bellows Micro	–	–	f/16	optional gelatin-filter holder
25mm f/2.5 Bellows Micro	–	–	f/16	"
50mm f/3.5 Auto Bellows Macro	–	–	f.32	optional gelatin-filter holder; 55mm filter w/ hood
100m f/4 Auto Bellows Macro	–	–	f/32	"
100mm f/4 Auto Bellows–	–	f/32	55mm	

Lenses of this type are ideal for recording the fine detail of coins, stamps and embroidered fabrics, as well as for more general photography. Many photographers substitute these lenses for their standard 50mm and 100mm optics, greatly increasing their focusing capabilities without giving up any image quality. The only drawback to using these lenses for general picturetaking is their modest maximum aperture. In both cases, however, the maximum aperture is more than enough for most daytime photography.

The greatest virtue of the macro lens is that it does away with the need for bellows extension units or front-end close focusing attachments. The focusing mechanism of each will take you from infinity to half lifesize with no need for any special adjustment. If you happen to be making a photograph at a moderate focusing distance and notice some small object or tiny detail nearby, you need not stop to do anything but refocus on your new subject.

Most macro lenses have accessory lifesize adapters available. With one of these attached, you can make extraordinarily sharp lifesize renditions of a world that is barely perceptible to the unaided eye. The adapters mount on the camera just like a lens does. Once the adapter is in place, the macro lens can be attached to the adapter via the same mount type that your camera body uses; the entire process takes seconds.

Fisheye Lenses

Fisheye lenses are the widest of all, taking in an angle of view of 180 degrees. Everything lying directly in front of you and your camera, parallel to the film, will be recorded by a fisheye lens. The depth of field of a fisheye lens extends from a few centimeters to infinity, even at its widest aperture.

Unlike conventional lenses, which are designed to provide the most distortion-free renditions possible for their focal lengths, fisheye lenses are made to give large amounts of a defect known as *barrel distortion*. Barrel distortion causes straight lines to bow outwards as they approach the center of the image. It makes no difference whether or not you hold the camera level; straight lines will appear curved. This effect is extremely useful for mapmaking and other scientific pursuits, and can also produce pictorial images ranging from the startling to the absurd.

There are two basic types of fisheye lens: the full-frame fisheye, which gives a fisheye picture that completely fills the film area; and a circular fisheye, which produces a round image at the center of the 24mm × 36mm frame.

The front elements of fisheye lenses are extremely large and deeply curved; conventional filters cannot be used with lenses of this

A circular fisheye lens will produce a round image at the center of the film frame, and when used with the right subjects can produce startling — and often amusing — results. Photo: R. Sammon.

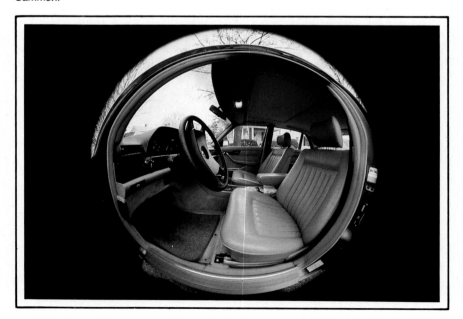

The curvilinear 16mm fisheye lens produces an image that fills the entire frame. The deliberate use of the defect known as "barrel distortion" causes straight lines to curve outwards around the center of the image. For this reason, the lens is used most effectively on subjects having normally parallel lines. Photo: D.E. Cox.

type. Some fisheye lenses have built-in filter turrets, providing all of the most commonly needed filters at the turn of a ring on the lens barrel.

For general photographic work, the full-frame fisheye lens is more useful than the circular type. A 16mm fisheye is an interesting alternative to a rectilinear 17mm ultra-wide-angle lens. Even though only 1mm of focal length separates them, the 16mm fisheye provides 76 degrees more field of view; its curvature of straight lines produces a completely different rendition of your subject than does the more conventional 17mm lens.

SPECIFICATIONS: MINOLTA FISHEYE LENSES

Lens	Angle of View	Minimum Focus	Minimum f-Stop	Filter Thread Diameter
7.5mm f/4 MD	180°	0.5m (1.6 ft)	f/22	built-in
16mm f/2.8 MD	180°	0.25m (0.8 ft)	f/22	built-in

Mirror lenses produce characteristic donut-shaped forms from out-of-focus highlights, and many photographers deliberately attempt this effect. If you desire this effect, seek out backgrounds that are brightly lighted or highly reflective. Photo: R. Hanshe.

Mirror Lenses

Imagine a 500mm lens that weighs less than 0.7kg (1½ lbs), focuses as close as 4.6m (15 ft), gives razor-sharp results, and can be hand-held at 1/500 sec. with confidence. Impossible? Not if the lens is a *catadioptric*, or mirror, type. Catadioptric systems were first used in telescopes. They combine conventional lens elements with curved, highly polished mirrorlike discs that have holes in their center—not unlike mirrored donuts.

Light entering a mirror lens reaches the rear of the lens barrel, where a mirror reflects it back towards the front. There, a smaller mirror sends the image-forming rays towards the rear once again, onto the film. This "folding" of the light rays is used to reduce greatly the physical length and weight of lenses with extremely long focal lengths.

Catadioptric lenses have only one aperture; their design does not include an iris diaphragm. Since there is no way to change the f-stop, the camera's shutter controls exposure. As a further exposure aid, most mirror lenses can be fitted with neutral density filters to cut down the amount of light passing through.

The donut-shaped mirror discs in catadioptric lenses produce characteristically donut-shaped out-of-focus highlights in your pictures. These rings of light can create a pleasantly graphic backdrop for nature studies and marine photographs. Be careful, though; at times they can be distracting in your pictures, even though they did not seem particularly disturbing in the viewfinder. If you examine the scene carefully through your mirror lens, you will spot potentially trouble-

some placement of these highlights. Usually, a slight change in camera position will let you arrange the background more effectively.

If you have a multi-mode Minolta SLR, the manufacturer recommends using the aperture-priority mode for automatic exposure control. Neither fully programmed automatic SLRs nor cameras with a shutter-priority mode can be used with mirror lenses. Both programmed and shutter-priority modes rely on an iris diaphragm for exposure setting. Since mirror lenses have no diaphragm, accurate programmed and shutter-priority exposure are impossible. Even though mirror lenses are lighter and smaller than conventional lenses of the same focal length, you must still support the camera firmly at moderate and slow shutter speeds. Generally speaking, you will get sharp hand-held results with mirror lenses at speeds that are the reciprocal of the focal length. With a 250mm mirror lens, use a tripod for any speed below 1/250 sec.; with a 500mm mirror lens, do not hand-hold the camera at speeds below 1/500 sec., and so on.

Mirror lenses, especially the longer ones, are not for casual work. They are highly specialized instruments built for those who need extremely portable super-telephoto lenses. There are a few exceptions, especially in the 250mm range, which are lightweight and compact enough to fit in any gadget bag. Such lenses are extremely useful to travel photographers, newspeople or anyone needing a medium telephoto without the weight.

The advantage of mirror lenses is that they offer long focal lengths without the size and weight of conventional telephoto lenses of comparable focal lengths. Compare, for example, the 600mm conventional telephoto lens at left and the 500mm mirror lens alongside it.

SPECIFICATIONS: MINOLTA MIRROR LENSES

Lens	Angle of View	Minimum Focus	Minimum f-Stop	Filter Thread Diameter
250mm f/5.6 RF	10°	2.5m (8.2 ft)	f/16	integral lens-element type
500mm f/8 RF	5°	4.0m (13.1 ft)	f/16	"
800mm f/8 RF	3°10'	8.0m (26.2 ft)	f/16	"
1600mm f/11 RF	1°30'	20.0m (65.6 ft)	f/22	"

VFC and Perspective Control Lenses

One of the most interesting and unique lenses is the VFC type. VFC stands for "variable field curvature," meaning that the normally flat field of the lens can be curved so that it becomes concave or convex, to match the curvatures of various subjects.

Under normal circumstances, the field over which a lens provides a sharp image is more or less flat, to match the flatness of the film. Although most subject matter is three-dimensional, the depth of field of the lens will usually render most subjects sharply at moderate focusing distances. However, there are instances when your subject is too close or elements in the scene too widely spaced for the depth of field to produce sharp images of everything you need rendered sharply. The variable field curvature control of the VFC lens will let you curve the

One of the prime uses of the VFC lens is in situations where the elements of a scene are too widely spaced for the depth of field to produce a uniformly sharp image when such an effect is desired. In the top photograph, taken with a conventional lens, the back row of ball is out of focus. In the photo below it, taken with a VFC lens, the back row is as sharp as the front row. The effect may also be deliberately reversed.

field over which a sharp rendition of the subject is produced. A special ring in front of the focusing control of the lens is clock-stopped to provide varying degrees of curvature; you can observe the effect through the lens, so you know exactly how the changes will affect your subject. With the curvature control in its normal position, the lens becomes an extremely sharp conventional wide-angle lens. The field curvature can be purposely altered in the opposite direction, to throw specific areas of the subject deliberately out of focus for expressive reasons.

PC, "perspective control" or "shift" lenses, are designed with the architectural photographer in mind. These lenses have extra large elements and greater covering power than are normally needed for the 24mm × 36mm dimensions of a 35mm film frame; their shifting controls allow you to move the front part of the lens up, down or to either side. In effect, the shift lens makes a small view camera out of your

SPECIFICATIONS: MINOLTA SPECIAL-PURPOSE LENSES

Lens	Angle of View	Minimum Focus	Minimum f-Stop	Filter Thread Diameter
24mm f/2.8 MD VFC	84°	0.3m (1 ft)	f/22	55mm
35mm f/2.8 Shift CA	63°	0.3m (1 ft)	f/22	55mm
85mm f/2.8 Varisoft	29°	0.8m (2.6 ft)	f/16	55mm

Minolta SLR. By keeping the camera parallel to a tall building and shifting the front part of the lens upwards, you can include the top of the building in your picture without causing the converging lines you would get if you took a conventional lens and tilted it and the camera to get the top of the building. Shifting the lens sideways will let you eliminate unwanted reflections in windows, or remove trees and cars from the edges of your picture. Trying to eliminate these obstructions by shooting from a different angle with a conventional lens will cause parallel lines to converge. With the shift lens, all lines that are parallel will stay that way.

The 35mm f/2.8 Shift CA also has variable field curvature; this and its shift capabilities make it one of the most versatile lenses available to the architectural and still-life photographer.

3

Exposure and Film

Modern 35mm SLR cameras are marvels of exposure accuracy and automation. In most picturetaking situations, all you need do is aim your camera, focus and press the shutter release. The resulting photographs will be perfectly exposed, with an abundance of detail and tone. Much of this high image quality is provided by the sophisticated exposure measuring and setting devices built into the camera; but much of it is also due to the steady advances that film manufacturers have made

Each different film type has its own special attributes and limitations. Some films are relatively low in their sensitivity to light, requiring a good amount of illumination to record an image. This usually means that they have to be used at slow shutter speeds and large lens openings in moderate or dim light, making them of limited use for moving subjects. However, these low sensitivity, or *slow,* films are capable of reproducing the finest subject details with fidelity.

Fast films—those that are extremely sensitive to light—will let you make hand-held photographs in moderate and reasonably dim light; they will also allow you to use fast shutter speeds to freeze the motion of fast-moving subjects, or to shoot at small lens openings to get more depth of field. The price you pay for this increase in sensitivity is that your results will be somewhat more grainy and less suitable for extreme enlargement. Films that have a sensitivity somewhere between these two extremes are best for general work in moderate light.

From time to time, you may find yourself in lighting that is too weak for your camera's built-in metering system to handle; or there may be occasions that demand an alternate metering method to the simple one of pointing your camera at the subject and letting its automatic exposure system do the rest. A more sensitive, auxiliary hand-held light meter will be a great help in both situations, as will a careful light measurement of specific subject areas. The following pages discuss the tools and techniques that will help you get the best possible results from your film.

Correct exposure may be difficult to achieve in a situation where parts of the scene are more brightly lighted than others. Techniques for exposure control are described in this chapter. Photo: B. Sastre.

Exposure

The through-the-lens metering systems of your Minolta SLR are extremely sensitive, responding quickly to the light coming from your subject. Coupled with the sophisticated automatic exposure system, they provide accurate exposures in virtually all of the situations in which you might find yourself making pictures; but only if you take a few simple steps before releasing the shutter.

First, make sure that the batteries in your camera are fresh and functioning properly. Most Minolta SLRs have battery-check switches that you can key in to determine the health of the camera's power source. Another way to check is to turn the camera's power switch on, then point the camera at a reasonably well-lighted part of the scene. One of the shutter speed-indicating LEDs in the viewfinder will glow if the batteries are working.

Once you have checked the batteries before using the camera, make sure that the correct film speed has been set. Each film has a specific degree of light-sensitivity, marked on the cassette and the film box in terms of ISO numbers. Set the speed of the film onto the camera's film speed dial, to make sure that the exposure controls allow the correct amount of light through for the film to respond properly to your scene.

Dramatic effects can be achieved with creative exposure techniques. Had the photographer attempted to expose for the overall scene, with its enormous range of light and dark areas, the result would have been possibly acceptable but certainly bland; there would be more detail in the dark areas but the lighter areas would be overexposed and less well saturated. Instead, he chose to emphasize the bright colors of the woman's robe and the general form created by the pattern of the light. Photo: J. Isaac.

Choice of film and how it is used are important control tools in making effective photographs. Color saturation (richness of color) may often be controlled by exposure. Here, strong, vibrant oranges and subtle greens were produced in the water and reflected sunlight by underexposing the film and letting the land area to the right of the frame form a dark, undetailed mass. Photo: L. Clergue.

Negative films, both black-and-white and color, need a slightly different exposure technique than transparency (slide) films do. Negatives produce an opposite tonal rendition of the scene; each light subject tone is rendered as a relatively dense, dark area on the negative, while darker subject areas are rendered as light or almost transparent. When the negative is printed, its lighter portions let through more illumination from the enlarger than do the denser ones, causing the print to have dark tones where the scene did. To expose a negative film properly you must let enough light from the important dark areas of the scene through to produce detailed rendition on the negative; too little light will cause the shadow portions of your picture to appear as featureless dark or black tones. In other words, you should *expose for the shadow areas;* the film should then be developed just long enough to produce clean, separated bright tones in the highlight portions of the negative.

Transparency films, on the other hand, must be given just enough exposure to produce detail in the bright areas of the scene—no more —or these highlight areas will appear washed out and weak-looking. When you use transparency films, you should *expose for the most important bright areas* of the photograph, letting the shadows take care of themselves. Since the transparency film is itself the final product, there

Bracketing is a technique used by many photographers in situations where they are not entirely certain that the "average" readings of their exposure meters will give them the effects they desire. The technique is simple: one exposure is made at the suggested meter reading; then other pictures are made by increasing or decreasing the exposure by half stops. One or several of the alternate exposures may be more acceptable than the suggested reading. The photo at left is underexposed; that below is overexposed. The photo below left represents the most acceptable of the three bracketed exposures. Photo: B. Sastre.

is no way to adjust for overexposed highlights in the darkroom—you must record them with enough detail while exposing.

In most picture situations, the centerweighted metering system of your Minolta will balance out the light and dark portions of the scene, providing camera settings or suggestions that will give you well-exposed pictures no matter what kind of film you have in the camera; usually, you will not have to worry about metering specific areas of the scene. Still, you may find that the following two tips will improve the rendition of many subjects:

Technique Tip: Exposure for Color Film

- When shooting with negative film, you can often increase the quality of the shadow rendition by setting your camera's film speed dial to a number slightly lower than that of the film you are using. For example, using ISO 400/27° negative film (both black-and-white and color) with the camera's film-speed dial set at 320 will give increased exposure to the shadows without unduly affecting the rendition of the brighter areas. The result will be increased shadow detail.

- To guarantee yourself the best color rendition of your transparencies, *bracket* your exposures. Make pictures at the recommended settings; then use the camera's exposure compensation dial to change the automatic exposure settings about a half-stop in either direction. One of the three exposures will usually give you a color rendition and saturation you will be pleased with.

Many photographers prefer richer colors than the "accurate" exposure gives them; they routinely set their film speed dials to a number that is slightly *higher* than that of the film they are using. Try this for yourself: Using the automatic mode of your Minolta, shoot a roll of film at the "correct" film speed setting; then set the film speed dial to a speed about a half-stop faster than the manufacturer's recommended speed, and shoot another roll in the same surroundings. Send both in for processing, and compare the results. You may find that you, too, prefer the deeper hues slight underexposure will give you.

All of the suggestions made so far apply to general picturemaking in average lighting situations, using your camera's built-in meter. For difficult lighting, you might have to use an off-camera meter, or amend the camera's exposure decisions to suit the situation at hand, as described in the following section.

When the Camera's Meter Can Be Fooled

In spite of the sophisticated technology that goes into the making of a through-the-lens light metering system, the meter itself (and therefore the automatic exposure modes controlled by it) is designed to accomplish one simple task: to give exposure recommendations or commands that will reproduce the object it is measuring as an 18 percent reflectance "middle gray." It makes little difference what your subject is; if you have black-and-white film in your camera and use the meter's recommended settings to take separate pictures of a gray object, a white one and a black one, filling the frame with each, all three will be rendered in more or less the same grayish shade. The reason that light meters and automatic exposure cameras can work at all properly is that the highlights, middle tones and shadows of most subjects average out enough to let the meter's reading provide an exposure that adequately renders the relative brightness of various objects in the scene. Unfortunately, not all photographic situations have such an evenly balanced distribution of light and shade; there are a number of commonly encountered instances when taking your camera's metering system at its word will produce a photograph that is a far cry from what you expected. Here are some situations you may run across, if you haven't already, along with suggestions about how to overcome your meter's lack of interpretive powers.

Strong backlight will give a silhouette effect when a through-the-lens meter is used to make an exposure reading of an overall scene. For more detail in the girl's face, a closeup reading would have been necessary, and the foliage in the background would have appeared less brightly colored because of overexposure. Photo: L. Jones.

In order to expose for the highlighted details in the falling water, the photographer deliberately underexposed the rest of the picture. Note the intense blue of the sky and the rich greens of the foliage in the background, as well as the lack of details in the more deeply shadowed areas of the photograph. Photo: M. Fairchild.

Backlighted and Sidelighted Situations. If your subject is between you and the sun or other bright light-source and you expose at the meter's suggested settings, your subject will be rendered far darker than normal. If the light is particularly intense, your main subject will become silhouetted, with hardly any discernible detail. In spite of the fact that your Minolta's metering system is center-weighted, taking most of its reading from the central portion of the viewfinder, enough of the light from behind your subject will be read to give the metering cell an inflated appraisal of the scene's brightness.

Solution: If you are using your camera in the automatic mode, set its exposure compensation dial to about $+1\frac{1}{2}$ or $+2$ stops. The increase in exposure will compensate for most backlighted situations.

For extremely bright backlight, a closeup reading may be in order. Move as close to your subject as you can, filling the frame with the most important area. If you use a fully programmed automatic camera, make a reading of the area and hold down the exposure lock switch as you step back to compose your picture and shoot. With other SLRs, make a closeup reading, then set the camera to the appropriate manual shutter speed.

If you want a complete silhouette effect and the back- or sidelight is not overly intense, the center-weighted meter might give you too much of a hint of detail in the main subject. In this case, set the exposure compensation dial to -1 or $-1\frac{1}{2}$ stops, or lock in a reading based on the bright areas of the scene only.

81

Reflections from bright surfaces like snow, sand and water can fool the meter into giving an underexposed reading. To properly expose a subject that is not at the center of the frame, take your reading from the main subject, then recompose the scene and shoot. Here, there is relatively little detail in the snowy background, but the red of the umbrella is rich and intense. Photo: L. Jones.

Bright Reflections and Light-Sources in the Scene. Reflections of the sun in glass or from highly polished pieces of metal can be strong enough to affect the meter reading. If you are shooting in an area with bright lamps, these can also affect the meter reading enough to throw off your exposure.

Solution: Make closeup readings as for backlighted subjects, or point the camera away from the bright lamps or reflections for metering. Make the appropriate exposure adjustments, recompose and shoot.

Composing Along the Edges. If your picture requires you to place your main subject away from the center of the viewfinder for the sake of composition, you may run the risk of making most of your center-weighted reading from an area that is substantially brighter or darker than your main subject. The result will be under- or overexposure, respectively, of the main subject.

Solution: Center your subject in the finder for metering only, adjust the camera settings accordingly, then recompose the scene to your liking and shoot.

Main Subject Too Far Away. In a situation where the most important part of the scene is too far away for an accurate reading and you cannot get closer, make your reading through the longest lens you have at your disposal. The longer lens will magnify the image of the subject, making accurate readings easier.

If you find yourself needing to make readings of small subject areas or distant parts of the scene more than occasionally, you will find a spot meter useful. Spot meters are hand-held devices that make extremely accurate light readings along a very narrow viewing angle. There are three different spot meters in the Minolta system, each providing an angle of view of one degree. A spot meter will let you easily make accurate exposure readings of such subjects as lighthouses far offshore, (where the light from the sea and sky might affect your camera meter enough to give an erroneous reading for the lighthouse); individual faces in a large crowd; patches of trees in rocky landscapes and any other circumstances where closeup readings are impossible.

The key to overcoming your meter's inability to handle these and other difficult lighting situations lies in knowing which areas of the scene are the most important to the picture you are after, and to meter these areas only, ignoring those whose tones or distribution may cause your camera's meter to render the important areas incorrectly.

A scene like this, with the main subject (the windsurfer sail) at a considerable distance and surrounded by bright reflections, is difficult to expose accurately. A spot meter is extremely useful in such a situation. If one is not available, make your reading through the longest lens available; then switch lenses, recompose, and take your picture. Photo: L. Jones.

Hand-Held Light Meters

Not so long ago, most cameras had no built-in light metering systems; photographers would carry with them a small, hand-held meter to determine their exposures by. In this day of extremely accurate and responsive built-in metering and automated exposure systems, hand-held meters are still extremely useful. They have larger light-sensitive cells than the necessarily small in-camera meters do; consequently, hand-held light meters are often far more responsive in low light levels. Some models can provide exposure recommendations of up to 4 hours (most in-camera light meters will give accurate readings in light requiring exposures of up to 4 seconds, rarely longer); with special booster cells fitted, these extremely sensitive devices can be made even more so, to the point that thay can make accurate exposure determinations literally by moonlight.

There are basically two types of light meters: *incident-light* meters, which read the light *falling on your subject;* and *reflected-light* meters, which respond to the *light given off by* or *reflecting from* your subject. The light metering systems built into cameras are of the reflected type. Hand-held meters are available in both varieties; many of them can be easily adjusted to provide either incident or reflected readings, to best accommodate the kind of lighting you find yourself in.

Incident-Light Meters. One of the main advantages of an incident-light meter is that it measures the light falling *on* the subject, as seen from your shooting position. For example, if your subject is heavily

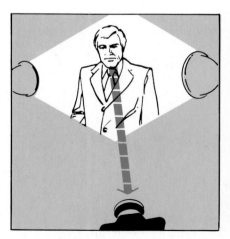 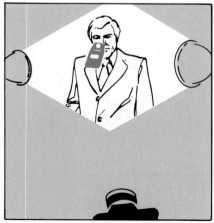

(Left) A reflected-light meter, like the one in your camera, measures the light given off by, or reflected from, the subject, and is used from the camera position. An incident light meter (right) measures the light falling on the subject and is used from the subject position. While reflected-light meters are accurate in most picturetaking situations, incident-light meters are more accurate when there is a considerable difference between the light falling on the subject and the light reflected from it, as in a backlighted scene.

backlighted, the incident light measurement will take into account only that light falling on your subject's front, ignoring the illumination from behind. This backlight would fool an ordinary, through-the-lens reflected-light meter, because much of the brightness behind your subject would reach the metering cells and cause erroneous readings.

By measuring the light illuminating the overall scene, incident-light meters will give you exposure recommendations that allow your subject's tones to be recorded in their proportionately "correct" relationships. Tones lighter than middle gray in the scene will be rendered lighter; those darker will appear darker than middle gray in the final picture. In most general lighting situations, shooting at the incident meter's recommended settings will give you extremely accurate exposures. This is true even if the subject is especially light or dark; by reading the light illuminating it instead of that reflecting from it, the incident meter's recommended exposure will record the tones faithfully.

Reflected-Light Meters. Reflected-light meters are used from the camera position, pointed at your subject. In most general picturetaking, they are capable of providing accurate exposure readings by averaging out the various amounts of light reflecting from different parts of your subject to provide an overall exposure recommendation that will render your subject's tones properly. With extremely bright or dark subjects, however, these readings have to be interpreted; shooting at the recommended settings will produce middle gray renditions of such objects as white dresses or black cats, if these occupy most of the picture frame.

Some reflected-light meters gave a very narrow angle of view. These are called *spot meters,* and are extremely handy when you need to make readings of small or distant parts of your subject. Each of these metering types is represented in the Minolta system.

Minolta's Autometer III (at left) can be used as both an incident-light and reflected-light meter. The Spot Meter II (at right) is a reflected-light meter that has a very narrow angle of view, providing accurate readings of small or distant parts of the subject.

Film Types and Qualities

The film you put into your Minolta is both the canvas upon which you paint your photographic world, and the palette from which you draw the basic colors and tones of your pictures. Choosing the film best suited for the job you have in mind is as important as selecting an appropriate lens.

Each film, black-and-white or color, has its own particular characteristics, strengths and limitations. In some cases, the differences between one film and another may be slight enough not to make much difference in general picturetaking; in others, the differences are radical enough to have a great impact on the "look" of your photograph.

Black-and-White Films. All films have certain inherent qualities by which they can be compared to one another. The most obvious of these is color reproduction. Black-and-white films record the colors of your subject in varying shades of gray. Depending on their color sensitivity, black-and-white films render subject colors with varying degrees of success. *Panchromatic* black-and-white film is more or less equally sensitive to all of the colors of the spectrum, producing an accurate gray-tone interpretation of subject colors. Most black-and-white films

Panchromatic black-and-white films translate the colors of a scene into accurate gray-tone interpretations. Photos: D.E. Cox.

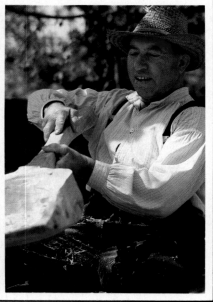

available in the 35mm format are panchromatic. *Orthochromatic* films are much less sensitive to reds than to other colors. Because of this, they are sometimes used to make pictures of swarthy men; the lower red sensitivity of orthochromatic film causes the lines in faces to be more pronounced, since skin tone is high in red content. Certain special-purpose black-and-white films are only sensitive to blue light. These *blue sensitive* films are of little use in general photography, but are indispensable for copying documents, blueprints and the like.

Virtually all black-and-white films are *negative* emulsions; they reproduce light areas of the subject as dark, silver-laden areas on the film. Dark subject tones appear as clear or nearly clear film areas. The paper used to make prints from black-and-white negatives works in much the same way, taking dark negative areas and turning them light in the print, and vice-versa. The end result is that the print you get has light tones where the scene was bright, and dark ones where the objects in the scene were dimly lighted or dark-toned.

Color Films. Color films use various kinds of chemical dyes to render the subject in hues that approximate those of the original scene. They can be negative films whose colors are transformed during the printing process, or *direct positive* ones, which reproduce the colors of the scene directly. Direct positive films are meant for projection, and are usually called transparency or slide films. No two color films are alike, and none available absolutely match the colors of the subject. The differences among them come from the kinds of dye used, among other things; these differences are a constant source of debate in photographic magazines. Each color photographer has his or her favorite color film; deciding which one reproduces color best is largely a matter of individual taste.

Film Speed. All films, black-and-white and color, have a relative degree of sensitivity to light. This light-sensitivity is referred to as *speed;* the more sensitive the film, the "faster" it is said to be.

A film's speed is determined by standardized tests given it under the control of organizations such as the American National Standards Institute (ANSI). ANSI used to be known as ASA (the American Standards Institute), which is where the term "ASA speed" came from. ASA speeds are arranged in an arithmetic progression; as the ASA number doubles, the relative speed of the film doubles, or increases, by one stop. An ASA 100 film is one stop faster that an ASA 50 film, for instance.

The German equivalent of ASA is DIN (Deutsche Industrie Norm). Its speed rating system is logarithmic—for each increase of three degrees in the DIN number, the film speed doubles. A DIN 21° film is one stop faster than a DIN 18° film (the degree mark alongside the DIN number shows that the progression is logarithmic, rather than arithmetic).

Other countries have their own film speed rating systems, though the two most commonly used throughout the world have been ASA and

DIN speeds. If you think all of these numbers are confusing, you are not alone; many photographers have complained about the counterproductive and cumbersome practice of having more than one film speed rating. Recently, the International Standards Organization came to the rescue, combining the two most commonly used systems into one. All films now carry an ISO rating. For instance, Kodachrome 64 has an ISO number of 64/19°; Kodacolor 400 is ISO 400/27°.

Film Granularity. The relative light sensitivity, or speed, of a film is closely tied to the size and distribution of silver salt grains in the film's emulsion. Films with small, evenly distributed grains are relatively slow; fast films have a mixture of large and small silver salt grains. Smaller-grained films usually produce more contrasty results than larger-grained ones, so slow films have more *inherent contrast* than fast ones, all other things being equal.

The smaller a film's granularity, the better it can reproduce fine details of a scene. The ability to render fine detail is called the film's *resolving power*. Slow films have far better resolving power than fast ones do. The resolving power of films is measured in special tests to determine how well the film being examined can separate groups of very closely spaced lines. This test, and another one made for *acutance* (the film's ability to delineate the edges of subjects sharply), help determine the film's *enlargeability*. All 35mm films are meant to be enlarged, either by printing or by projection onto a screen, so the enlargeability of a film is an important consideration. Generally speaking, slower, finer-grained films are capable of producing much better enlargements than fast, coarser-grained ones.

Film Graininess. A film's *graininess* is related to its granularity, but the terms are not synonymous. Graininess happens when the film's silver grains clump together during development or other processing stages. These clusters of grains become visible as a pattern referred to as graininess. The longer or more careless the processing, the more grainy the results. It is quite possible to produce a less grainy-looking picture from a carefully processed coarse-grained film than you would get from an overdeveloped medium- or fine-grained film.

Color Balance. If you use color film, you have one other consideration to take into account: the film's *color balance*. Many color films are designed to produce reasonably accurate results in specific kinds of light. *Daylight* films are meant to compensate for the bluish light found outdoors or with electronic flash. Using these films indoors with tungsten lighting will produce a reddish cast in your pictures. *Tungsten*-balanced films produce much bluer results, to counteract the reddish glow of indoor lighting. Using tungsten film outdoors or with electronic flash will produce a strong bluish cast that wreaks havoc on skin tones. All color transparency films are meant to be used in specific kinds of light; many color negative films can be used in either daylight or tung-

A film's resolving power—the ability to reproduce fine detail—is a function of its granularity. For a fine-grained, well-defined photo, use the slowest film possible under the available lighting conditions. For a stationary subject such as this landscape, slow film should present no problems, since slow shutter speeds may be used. Photo: P. Bereswill.

sten illumination—the color casts can be filtered out when prints are made from the negatives.

Exposure Latitude. All films have a certain amount of *exposure latitude*. Latitude is the film's ability to produce a usable result even if the exposure was incorrect. Faster films have more exposure latitude—you are not likely to get any sort of pleasing result if your exposure is off by more than 1 stop in either direction. Fast black-and-white films are the most forgiving of all, letting you make mistakes of about one stop under and two or three stops over the proper exposure before the quality of the result is seriously hampered. With all films, though, the best results are gotten from accurately exposed pictures; make sure your meter is set to the correct film speed, and make accurate light readings.

High-Speed Black-and-White Films

Black-and-white films with ISO speeds of 400/27° or faster are the mainstay of photographers who make their living in adverse lighting conditions, especially those where electronic flash or other added illumination cannot be used. They are also the first choice when the photographer is unsure of the amount of light he or she will be working in. Most of the pictures you see in your daily newspaper are made with high-speed films such as Ilford HP5, Kodak Tri-X and Agfapan Professional 400. They have been used to record events ranging from the Vietnam war to the marriage of Prince Charles and Lady Diana. These films are also preferred by many pictorial photographers, artists and amateurs who work in black-and-white.

Modern high-speed black-and-white films are far superior to their predecessors of just a generation ago. Today's ISO 400/27° films are finer grained and have much higher resolving power, making them ideal for all sorts of general photography, even when the light is far from dim. In bright daylight, for example, these films will give you the option of using smaller lens openings to increase depth of field, or fast shutter speeds to freeze movement.

High-speed black-and-white films do not have the enlargeability of slower ones; but even so, surprisingly large prints can be made from them, provided you expose properly and process them (or have them processed) with care. Beautifully detailed, fine-grained prints measuring 11" × 14" are routinely made by many high-speed film users; unless there is a lot of middle gray area in your picture (where grain is most obvious), extremely careful exposure and development will give you negatives capable of good enlargements up to 16" × 20".

Fast black-and-white films such as Tri-X have a considerable degree of exposure latitude. This does not mean that the film will make up for your exposure errors; but even if you manage to underexpose your film by one stop or overexpose it by three stops or so, you will get a printable negative.

Extremely Fast Films. If you find yourself needing pictures of subjects lighted too poorly for fast films, take heart—extremely fast films like Kodak's Recording Film 2475 and Agfa's Isopan Record are just what you are looking for. These films were designed for surveillance work and other special purposes, but are available in any well-stocked photographic store. The speed of these esoteric emulsions varies from EI*

*A film's EI (Exposure Index) is the best speed for the film as determined by an individual photographer in terms of the results he or she desires. A film's EI may or may not correspond with the speed recommended by the manufacturer, which is indicated by an ISO number and is determined by laboratory tests.

1000 to 4000, depending on how they are used and developed. The resolving power of these emulsions is far lower than that of conventional high speed films, and their granularity is quite noticeable.

Fast black-and-white films are extremely popular with photographers who cannot exercise a great deal of control over the lighting conditions in which they will be working. Such films allow them to shoot under a variety of conditions, varying aperture and shutter speed to control exposure. Photo: P. Bereswill.

Slow- and Medium-Speed Black-and-White Films

All other things being equal, you will get the sharpest and least grainy-looking pictures from slow black-and-white films such as Kodak Pana-tomic-X (ISO 32/16°), Agfapan 25 Professional (ISO 25/15°) and Ilford Pan F (ISO 50/18°). These films and others like them will give you results that look like they came from cameras using much larger formats than your 35mm SLR.

The extremely high resolving power of slow black-and-white films renders detail you may not have even been aware of while making the picture. The smallest wrinkle, the most delicate texture, the tiniest speck of information will be clearly defined in the negative. Until you have used one of these films, you may not really have an idea of the high quality your 35mm SLR is capable of.

Slow films are tailormade for shooting outdoors in open shade, or in any brightly lighted situation where the light is not too harsh. They are used extensively in architectural photography, still life, landscape and other photographic pursuits where the physical quality of the print is more important than being able to shoot quickly with the camera in hand.

Slow films tend to be less forgiving of exposure error than their faster counterparts. Take extra care to meter your subject properly. In evenly lighted situations, your Minolta's center-weighted metering system will provide good results in either aperture-preferred or programmed exposure mode. If the lighting is especially tricky, make closeup readings of faces or other important areas of your scene, then use the camera's automatic-exposure lock, or transfer the settings to the camera's manual mode. This way, you will avoid influencing the exposure by strong lights in the scene, by extremely dark backgrounds or by other error-inducing situations.

Slow films almost invariably demand slow shutter speeds; use a tripod and cable release whenever possible, to avoid camera shake. Even if the shutter speeds called for are moderate, you ought to consider using a tripod or other sturdy camera support. The slightest camera shake will undermine the startling fidelity slow films can produce; and since you are most likely to use these emulsions to record static subjects, the tripod will not be a hindrance. It may even help you slow down your shooting routine enough to help you apply a more thoughtful, methodical approach to your subjects.

If you find that the films mentioned are a bit too slow for your kind of picturemaking, but you still want better image quality than fast films will give you, try a medium-speed film like Kodak Plus-X (ISO 125/22°), Ilford FP4 (ISO 125/22°) or Agfapan 100 Professional (ISO 100/21°). These films have almost as much resolving power as slower ones, and their grain characteristics are finer than those of fast films. Medium-speed films are the best choice for general black-and-white photography under most daylight conditions. If you have never made

pictures with black-and-white film but would like to try, use a medium-speed film first. Chances are, you will rarely need any other type for the majority of your photographs.

Slow black-and-white films are preferred by studio portraitists and other photographers working in situations where the subject is relatively immobile and the lighting is controllable. A tripod is recommended for use with the slow shutter speeds often demanded by slow films. Although the use of slow films requires more care than is necessary with medium and fast films, the resulting print quality is impossible to match. Photo: A. Balsys.

Depending upon how it is processed, Kodak Technical Pan film may be used to produce images with varying amounts of gray tones. As used here, some areas of gray detail are present to provide texture, but the overall impression is one of dramatic high contrast. Photo: H. Weber.

High-Contrast Films

High-contrast films are used extensively in the graphic arts, and by photographers who specialize in document photography and copy work; they can also provide you with a source for highly expressive and unusual pictorial results, when used to make pictures of appropriately graphic subjects. These films render the objects they record in stark blacks and whites, with no intermediate gray tones. The photographs made with high-contrast films look like etchings or line drawings, allowing the most dramatic depiction of your subject's shape and form.

There are a number of different high contrast films available; most of them are sold in stores catering to graphic artists, rather than in camera shops. Two types, both made by Kodak, can be found in regular photographic stores, in 35mm size: Kodalith film and Kodak Technical Pan. Kodalith film is *orthochromatic;* meaning that it is not as sensitive to red light as it is to other colors; you can process Kodalith while using a red safelight. Kodalith film is very slow—ISO 8/10°, and will render red parts of the scene as black. Because of the high red content of indoor light, this film is even less sensitive indoors, and is therefore most useful with still-life and other static subjects.

A more versatile alternative for high-contrast photography is Technical Pan film. This emulsion is *panchromatic*—sensitive to all colors, with added sensitivity to reds. You can use it indoors and out at speeds ranging from 25 to 200, depending on the light source and what kind of developer you will use to process it. To produce the highest

contrast possible, use the film at an exposure index* of 200, developing it in Kodak Dektol developer as indicated in the table below. The results will have no midtones at all; dark objects in the scene will be rendered as silhouettes, while medium and light tones will appear pure white. The results may be too stark for some subjects, but will work well with such scenes as bridges, leafless trees, and others whose forms are set against a clean, uncluttered background.

USES OF KODAK TECHNICAL PAN

Results Wanted	Shoot Film at This Speed	Develop in	@ 20°C (68°F) for
Highest contrast	200	Dektol	3 min.
Extremely high contrast	160	D 19	5–7 min.
Very high contrast	50	D 76 or LD-11	8 min.
Moderate/normal contrast	25–32	Technidol LC	7–18 min. (as recommended on packet)

The above times are recommendations for small tank use, with gentle agitation every 30 seconds (one in version of the tank).

For pictures with a hint of midtones, use Technical Pan film at an exposure index of about 50, and develop it in D 76 or ID-11 developer. This will give you high contrast but with some sense of three-dimensionality. Subjects best suited for this use of Technical Pan include textured surfaces such as brickwork, or nature scenes where you want to show some detail in tree bark and leaves.

Technical Pan film is versatile enough to be used as a moderately low-contrast, general purpose emulsion as well. Kodak sells the film, along with a special low-contrast developer, in kit form. Used at an exposure index of 25 and developed in the Technidol LC developer supplied in the kit, Technical Pan will produce full-toned, brilliantly sharp photographs with no visible grain—the kind of result you would expect from a view camera, rather than a 35mm SLR.

Besides the two films mentioned, there are a number of large-format sheet films that can be used in the darkroom to make high-contrast negatives and prints from normal contrast negatives you may have already made. Kodak Translite film #5561, for example, can be used as though it were printing paper. It has a frosted finish, appearing like vellum or tracing paper, and can be drawn on or hand-colored after you have made your picture on it.

*For an explanation of exposure index, see the footnote in the section "High Speed Black-and-White Films."

Infrared Films

All conventional films are designed to respond to light that falls within the visible spectrum—the relatively narrow band of electromagnetic energy that makes up the light by which we see everything around us. There are some special-purpose films that are sensitive to wavelengths falling outside those that make up visible light. The x-ray films used by your doctor or dentist are examples of this. Most of these special-purpose films are useless for general photographic use, but there is one type that can provide you with an exciting, alternative way to picture the world: infrared film. Infrared films are sensitive not only to visible light, but also to wavelengths that are somewhat longer than those we see. These infrared wavelengths fall somewhere between those that make up red light and those we sense as heat. There are both black-and-white and color versions of infrared film available; both can be used to produce pictures that are startlingly different from the way they would look if conventional film were used.

Black-and-White Infrared. Black-and-white infrared films are used in surveillance work, where pictures have to be made in the darkness, with no additional lighting that could be seen by the subjects; and in certain kinds of scientific photography, to determine the onset of crop diseases or the degree of water pollution, among other applications. Depending on the amount of infrared radiation present in a scene, these films can also produce daytime scenes that look as though they were photographed at night, with almost black skies and light foliage. Clouds stand out far more than they would if conventional films were used, and human skin tones have a glowing, unreal appearance that evokes a dreamlike quality. There is no way to accurately predict the effect of infrared film on a subject, because to date no one has come up with an accurate way to conveniently measure the amount of infrared radiation present in a scene. However, by using filters, you can control the way infrared film responds to the amount of existing infrared radiation.

Using infrared film without filters leaves you at the mercy of nature; if there is a substantial amount of infrared radiation present, the photograph will look substantially different than it would made on conventional black-and-white film. In most cases, though, the visible blue and red wavelengths that exist in normal "white" light will overpower the infrared wavelengths, giving you a grainy but more or less conventional rendition of the scene. To make the film respond mostly to the infrared radiation given off by your subject, use a red filter. The deeper the filter's hue, the more you will "tailor" the film's response to infrared. Special visibly opaque filters are made to completely eliminate the visible light while allowing the infrared radiation to pass through onto your film.

Black-and-white infrared films usually have speeds of about ISO 100/21°, depending on their maker; but these film speeds are merely rough guides, since no one can predict how much infrared radiation there will be for the film to respond to in any given situation. When you use black-and-white infrared films, begin with the manufacturer's recommended speed, then make a series of exposures, in half stops, that are up to two stops more and two stops less than the recommended exposure. In most cases, this will guarantee you at least one exposure that will result in a good print.

You can further increase your success with infrared films if you use electronic flash with a deep red or infrared filter over the flash head. Many manufacturers supply deeply hued gels for this purpose. In dark situations you can dispense with the filter over your lens, using the filtered flash as your sole light-source. One or two manufacturers make a special infrared electronic flash unit for those who work extensively with infrared films.

Black-and-white infrared films produce surrealistic effects. Skies appear darker than normal, foliage lighter, and the entire scene appears bathed in a strange, otherworldly light. The grainy effect exhibited in this photograph is also characteristic of such films. Photo: H. Weber.

Black-and-white infrared films require a slightly different focusing technique than conventional films do. The infrared radiation comes to a point of focus that is slightly different from the one you see as sharp while focusing the lens. To compensate for this, most lenses have an infrared focusing mark or line slightly to one side of the conventional focusing index mark. Focus your lens normally, make a mental note of the distance, then set that distance against the infrared focusing index. In any event, the image will never be quite as sharp with infrared film as it is with conventional film; but in most cases this slight softness improves the effect.

Infrared films must be loaded and unloaded in *complete* darkness, to avoid fogging. Load your camera in the darkroom, or take along a changing bag. *Never* take the film out of its protective container, even in subdued light. Leave the cassette in its plastic container until you are ready to use the film; after shooting a roll, place it back into the container immediately.

Color infrared film changes the actual colors of objects, often unpredictably but almost always with fascinating results. Experiment with colored filters and different exposures for varying effects. Here, a fisheye lens was also used to enhance the bizarre quality of an infrared color image. Photo: P. Eastway.

Color Infrared. At present, the only color infrared film available to 35mm photographers is Kodak's Ektachrome Infrared, designed for daylight use or for indoor use with electronic flash. Unlike black-and-white infrared film, which changes the relative brightness rendition of objects that give off infrared radiation, color infrared film changes the actual color of the objects. Green plants may appear as bright red, brick buildings might become blue, and skin tones might take on a greenish or turquoise cast. The results are seldom predictable, but usually fascinating. Using yellow or orange filters normally reserved for black-and-white films will give you even more exaggerated false color results. There are no rules or regulations for pictorial use of color infrared films; experiment with various filters and bracket your exposures widely to guarantee yourself of a usable exposure.

Unlike black-and-white infrared film, color infrared can be loaded and unloaded in subdued light. Focusing is also done in the conventional manner, using the focusing index you use with normal films.

An unfiltered infrared photograph (left) of dark green leaves on a gray wall turned the leaves pale and the wall purple. When a red filter was added (right), the wall became green and the leaves yellow. Photos: J. Kalikow.

Color Films

Like black-and-white films, color films differ from one another in their speed, resolving power, granularity and contrast. A wide variety of different speed color films is available for 35mm photography, each having its advantages in certain shooting situations. These will be discussed later; but first, let us take a look at two other main categories that all color films fall into. The first of these has to do with the kind of final result the color film provides. Color *negative* films record the subject in tones that are complementary ("opposite") to the original colors òf the scene; these complementary tones are reconverted to the subject's original colors when prints are made. Color *transparency* or direct reversal films are designed in such a way that after processing, the original subject colors appear directly on the film itself. Transparency films are used for projection as slides, or can be used to make prints using special printing papers.

Both color negative and transparency films are made to accurately record subject colors in specific kinds of illumination. *Daylight*-type films are to be used in outdoor situations or with electronic flash, which produces a light quality similar to that of noon sunlight; *tungsten* films

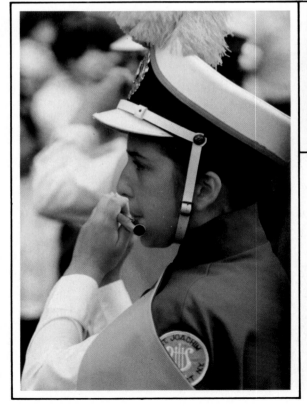

Color negative films record the subject in tones that are complementary to the actual colors of the scene; it is difficult for the untrained eye to predict what the final image will be. Negative films are used when a print, rather than a transparency, is the desired final result. Photo: B. Sastre.

Slow-speed color films give beautifully saturated colors and fine resolution of detail. The hard-edged graphic pattern depicted here is clearly enhanced by the contrasty, fine-grained quality of the film used to reproduce it. Photo: D.E. Cox.

are balanced for use with photographic lamps indoors. Most color negative films are of the daylight type, but can be used indoors without too much difficulty since any imbalance in the lighting can be corrected by filters used when prints are made. This means that in most cases you can use the same color negative film both indoors and out, without needing any special filters on your lens.

Since the final product of a transparency film is the film itself, there is no opportunity for filtering after exposure to match the film's color balance to the lighting. Thus, for the most accurate color rendition and best use of the film's speed, you should always use daylight-type transparency films for outdoor photography and for all of your electronic flash pictures. Using tungsten-balanced films outdoors or with flash will give your pictures an unpleasant bluish cast. For transparency pictures made in indoor lighting without flash, use tungsten-balanced film. Daylight-balanced film used in tungsten light will produce overly reddish results.

To overcome unpleasant color casts caused by using films of inappropriate color balance, special conversion filters are available: bluish ones for daylight film used with tungsten light, and salmon-colored ones to warm up the blue rendition given by tungsten film used outdoors. These filters do cut down on the amount of light reaching your film, and never quite match the color fidelity obtained by using the

In bright sunlight, especially with stationary subjects, slow films are ideal, providing beautifully saturated colors and exquisite detail. Photo: D.E. Cox.

In outdoor situations where the light is variable, medium-speeds are recommended, especially when fast shutter speeds or small apertures may be required. These films give you a variety of exposure options under most normal shooting conditions. Photo: D.E. Cox.

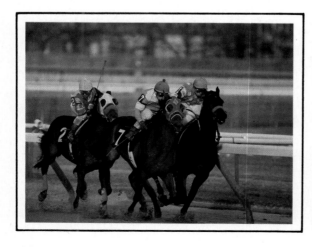

For the short shutter speeds needed to capture rapidly moving subjects, fast films provide the wider apertures required for proper control of exposure. Photo: P. Bereswill.

right film in the appropriate kind of light; still, they do provide good enough correction to make them worthwhile tools. Color conversion filters are discussed in detail in chapter 4.

Slow-Speed Color Films. Slow-speed color films, both negative and positive, have far less noticeable granularity than faster ones. They tend to be somewhat more contrasty and give beautifully saturated colors, and are capable of resolving extremely fine details. If you are photographing in bright light and want the richest colors possible, along with clearly rendered depictions of your subjects' details and textures, use the slowest film the lighting will allow.

Generally speaking, slow films are less forgiving of errors in exposure than are faster ones. Meter your subject carefully; a half-stop mistake in either direction is all the exposure latitude certain slow color films will allow. This is especially true of slow transparency films, such as Kodachrome 25. Moderate or dim light will call for the use of slow shutter speeds with these films; use a tripod or other camera support to guarantee yourself the best sharpness possible.

Medium-Speed and Fast Color Films. The most useful general-purpose color films have ISO speeds between 100/21° and 200/24°. These films combine fine grain with excellent resolving power, good color saturation and enough speed for hand-held shooting in moderate light. They are ideal for general scenics, impromptu portraiture, nature photography, and various other picturetaking situations.

For dim-light and nighttime photography, films with speeds of ISO 400/27° or higher are the best choice. Their color rendition is somewhat less rich than that given by moderate-speed and slow color films, and their graininess is much more noticeable; but their considerably greater sensitivity to light far outweighs their limitations.

Improvements in the color rendition and graininess of all color films, especially the faster ones, are being made all of the time. Recently, Kodak introduced a color negative film with the up-to-now unheard-of speed of ISO 1000/31°. This new super-fast film has better color saturation and finer grain than that given by many slower films of just a generation ago. This film, and the others that are sure to follow from various manufacturers, make available-light color photography easier than ever before.

Fidelity of Color Films. There is no color film that will exactly reproduce the colors of your subject. Each film type has its own color characteristics; different manufacturers have differing ideas about just what kind of palette to supply their customers with. Try various types of color films, to see which one most readily matches your own color sense. Make your own comparison test by photographing the same subject at the same shooting (to guarantee yourself the same lighting conditions) with a variety of color films. If possible, include a color chart in the scene, so that you will have some objective way of assessing the differences.

Chromogenic Films

Until recently, the only way you could get extremely fine-grained black-and-white photographs was to use very slow films. If you wanted to make photographs in extremely dim light, or needed to freeze action with fast shutter speeds, you had to make use of the few very grainy, relatively low-contrast super-speed black-and-white films available. In either case, you were limited by the exposure latitude of the film—making both kinds of picture mentioned on the same roll of film was next to impossible. No more. There are now two specially designed black-and-white films on the market, either of which will let you shoot subjects in both bright light and extremely dim illumination on the same roll, with no sacrifice of tonal quality or graininess. These films are called *chromogenic* emulsions, using special dye couplers to form the image during development. Ilford's version is called XP1; Agfa calls its chromogenic black-and-white film Vario-XL. Both films have a nominal speed of ISO 400/27°, but can be used to make exposures at ISO 200/24° to 1600/33° on the same roll. The graininess of a chromogenic film's negative depends on the amount of exposure it gets. Those exposed at ISO 200/24° will have extremely fine grain: those shot at the higher ratings will be a bit more grainy, but still far less so than

A subtle and almost infinite variation of gray tones is produced by chromogenic films. In addition, the exposure latitude of these films is much greater than that of ordinary black-and-white films, allowing you to produce fine-grained images under any exposure conditions. Photo: M. Ziegler.

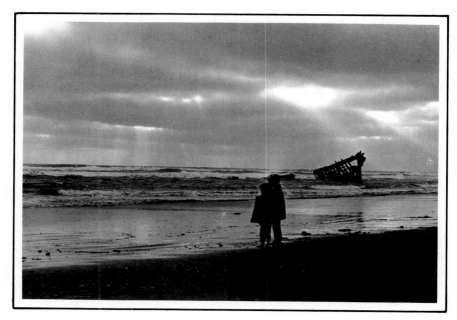

negatives made on conventional black-and-white films. The combination of high speed capability and small grain size makes chromogenic films viable contenders for the title of "all around" emulsions, especially because their tremendous exposure latitude all but eliminates the risk of lost pictures due to exposure errors.

Chromogenic films are constructed somewhat like color negative films; all of the silver in the emulsion is removed and replaced by dyes during development. The dyes of chromogenic films provide an almost infinite variation of gray tones; the prints made from these negatives have beautiful gradation and remarkably high resolving power.

Like color negative films, chromogenic films must be processed in color developer and bleach/fix, rather than in conventional black-and-white developers and fixers. Both Ilford and Agfa package home developing kits for their respective chromogenic films. Either film can be processed by any color laboratory in standard C-41 type color chemistry, with excellent results; but for the highest possible quality from these films, use the manufacturer's processing kits.

Chromogenic films are more costly than their conventional counterparts; the chemicals needed for processing are more costly as well. In spite of this, you may find these remarkable films a bargain, considering their high image quality and usefulness in a wide range of lighting situations.

Technique Tip: Processing and Printing Chromogenic Films

If you process your chromogenic film at home, you might be alarmed at the milky appearance of the negatives as you take them out of the wash water. This is a normal property of the film, and will clear as the film dries.

Unlike conventional black-and-white film, chromogenic film looks shiny on both sides when processed. Make sure you place the negatives in your enlarger correctly by checking to see that the frame numbers along the film's edge are not projected backwards.

Chromogenic films, even through they are processed in color processing solutions, will provide negatives that are used to make black-and-white prints on conventional black-and-white papers. Make your prints as you would with any conventional black-and-white film. You may find that exposures you made at ISO 200/24° look somewhat more dense than those you are used to. This is normal; simply increase the exposure time during printing.

4

Filters and Front End Attachments

Filters are to a good photographer what seasonings are to a good cook. Their best use, in either case, is to enhance the qualities of fundamentally good ingredients rather than to hide the flaws of poor ones.

Screwing a filter onto your lens will rarely make a dull scene less boring; but choosing the correct filter and using it in the right way can sometimes mean the difference between a good picture and a great one.

In other cases, filters are essential simply to record the image properly: color films, for example, are designed to function accurately in specific kinds of light, and you may need to use a filter that makes the light passing through your lens compatible with the film. In black-and-white photography, filters are used not only for expressive purposes (to bring out clouds and so on), but for technical ones as well— to separate colors that otherwise would look the same shade of gray; to increase haze penetration for sharper renditions of distant objects, to counteract the dirty-looking gray tones that aged documents sometimes produce when they are copied photographically and to solve countless other photographic problems.

In the right hands, photographic filters are powerful visual tools. They can turn daylight into nighttime, inject tonal separation into low-contrast subjects and bring to life moods that existed in the photographer's mind as he or she looked at the scene, even though the scene in question looked completely different. They can add character to robust faces, and an extra measure of softness to gentle ones. In short, filters can help you fully realize the potential strengths of your pictures by overcoming the limitations of the light falling on your subject. The following pages will give you a look at how filters affect the light passed through them, and how these effects can give you an extra measure of control over your picturetaking.

A wide variety of filters are available to help you expand the creative potential of your basic photographic equipment. Here, two filters were used: an orange filter to intensify the colors of sunset; and a diffraction grating to break up the sunlight into rainbow parts. Photo: D.E. Cox.

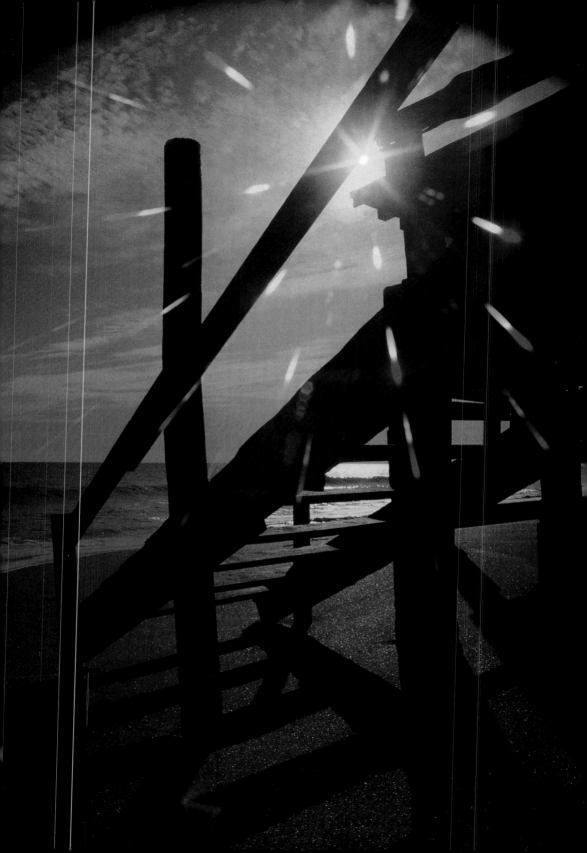

Filter Principles

The "white" light by which we see the world around us is made up of a combination of differently colored wavelengths, primarily red, blue and green. Photographic filters act as "optical blotters" of certain specific wavelengths, absorbing them before they can pass through the lens. For example, a red filter absorbs green and blue wavelengths from white light, leaving mostly red to pass through; blue filters stop the passage of green and red light, leaving only blue; and green filters retard the passage of red and blue. Because of this, strongly colored filters can be used in black-and-white photography to change the tonal rendition of a scene. By lessening the film's response to blue and red, for example, a green filter will lighten up the gray tone rendition of trees and grass; a red filter's ability to absorb blue wavelengths will cause the sky to produce less density on the negative than it would if no filter were used, resulting in a dramatic, sometimes nightlike appearance.

Deeply colored filters for black-and-white photography cannot be used for normal pictures with color films, since the film will produce an overall cast of the same color as the filter. The filters used in color photography are far more subtly tinted, designed primarily to produce slightly warmer or cooler renditions than the unfiltered film would provide.

Filters are also used in color photography to change the quality of the light reaching the film, so that it more closely matches the film's color balance. These warming, cooling and color-balancing filters provide a tremendous degree of control over the final outcome of your color exposures, especially if you use transparency films. While with negative films you can make slight changes in the color reproduction by

"White" light is composed mainly of red, green and blue wavelengths. A filter works by absorbing most of the light that is not of its color. By contrast, objects that are the same color as the filter appear more intense.

Polarizing filters reduce or eliminate polarized light, cutting out reflections and intensifying colors by removing the scattered polarized light that neutralizes or washes out colors. These filters will also increase the blue color of open sky without affecting other colors. Photo: D.E. Cox.

filtering during the printing process, once you have made your transparency exposure, you are stuck with it; filtering during exposure is often the only way to guarantee yourself of the kind of color slide you are after.

Certain filters affect the *amount* of light passing through the lens, rather than changing its makeup. Neutral density filters can be used with black-and-white or color films to reduce the light entering your camera on extremely bright days, when the lighting exceeds your shutter's ability to handle it. These filters will also let you shoot at specific lens openings if the light is too bright to do so otherwise. Graduated neutral density filters have clear lower portions, gradually getting darker towards the top. These help keep skies from getting overexposed on very bright days, while leaving the rest of the subject to record normally. Polarizing filters affect not only the amount of light reaching your film, but the way in which it travels, helping eliminate reflections. UV and haze filters absorb much of the invisible but haze-producing ultraviolet radiation found at high altitudes; at the other end of the spectrum, infra red filters can be used to absorb all visible light, letting infrared films record your subject only with the infrared radiation present in a scene.

Few photographers make use of all these different filter types; but one or two carefully chosen filters will give you far greater creative control of your film and the light reaching it.

Color Temperature

Color temperature has nothing to do with the actual caloric temperature of color; there is no such thing. Instead, it is an expression of the makeup or quality of different kinds of lighting. What we sense as "white" light—sunlight, open shade, incandescent illumination, or the light given off by photographic lamps of various sorts, all differ from one another in the relative amounts of blue and red wavelengths they are made up of. We do not see the difference because our brains compensate for it; a white dress will look more or less the same "shade of white" indoors and out. But color film can only respond literally to the makeup of the light it is used in. To the film, a white dress will look more yellowish indoors than it will outside because incandescent illumination has fewer blue wavelengths and more red ones than sunlight. Knowing precisely what combination of wavelengths makes up different light sources allows film manufacturers to balance the film's response to the light quality, so that the film will record object colors in a way that is accepted as "normal" by the eye.

Years ago, scientists discovered that, in theory, they could use an extremely black, completely non-reflective material to determine the relative distribution of red and blue wavelengths in light sources. The theory states that if you heat a piece of this non-reflective material, called a "black-body radiator," it will begin to glow a dull red. As the temperature increases, the material becomes orange, yellow, white, and finally blue-white. The higher the temperature gets, the more blue wavelengths are given off, at the expense of red ones. At any given color given off by the black-body radiator, its temperature can be measured on a scale progressing in degrees centigrade from absolute zero. The increments of this scale are called Kelvins (K), rather than degrees. By matching the color given off by the radiator to that of a light source, the *color temperature* of the light source can be written in Kelvins.

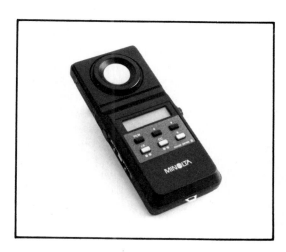

The Minolta Color Meter II measures the color temperature of light sources by measuring the relative distribution of red, blue and green wavelengths the source gives off. Once the meter is set for the color balance of the film being used, it assesses the makeup of the lighting in the scene and indicates whatever light-balancing filters are needed to produce accurate subject tones.

COLOR TEMPERATURE OF COMMON LIGHT SOURCES

Source	Color Temperature (Kelvin)
Open blue sky	12000–18000
Direct sun, noon average	5400–5500
Flashcube, magicube, flipflash	4950
Clear wire-filled flashbulbs	3800–4200
500-watt photoflood	3400
500-watt (3200K) photolamp	3200
200-watt household bulb	2980
100-watt household bulb	2775–2900
75-watt household bulb	2820
40-watt household bulb	2650
Candlelight	1885–1930

All of this is theoretical only because no perfectly non-reflective material exists in nature; but physicists have produced certain testing procedures and materials that come close enough to make the experiments and measurements useful.

How is color temperature useful in actual photographic situations? By knowing the color temperature of commonly encountered illumination, you can make meaningful decisions about what type of color film to use for accurate color rendition, or what filters to place in front of your lens to match the color temperature of the illumination in the scene to that of the film.

The higher the color temperature, the more blue wavelengths are present in the light source. Sunlight at noon, for example, has a color temperature of about 5500K. The light given off in open shade is comprised mostly of wavelengths from the blue sky. There are fewer red wavelengths in it than in direct sunlight; its color temperature can be upwards of 8000K.

The tungsten filaments used in incandescent lightbulbs work in much the same way as black body radiators (because they do reflect some light, they are technically referred to as "gray-body radiators"): the lower the wattage of the bulb, the less the filament heats up, and the more red wavelengths the bulb gives off. A modest household bulb of 100 watts gives a color temperature of about 2900K; a hotter-burning 200-watt bulb provides 2980K. Photolamps of 500 watts are designed to give off 3200K—the color temperature for which tungsten film is balanced.

Color temperature can only be properly measured from *continuous* light sources—those made up of wavelengths across the visible spectrum. Discontinuous light sources such as fluorescent lamps cannot be measured accurately in terms of their color temperature.

Light-Balancing Filters

Light-balancing filters are used by color photographers to make subtle adjustments to the relative red/blue balance of the light passing through the lens. These filters are bluish (82 series) or yellowish (81 series). The filters in the 82 series let you raise the color temperature of the light passing through the lens; if you were shooting under 100-watt bulbs and had tungsten-balanced film in your camera, the unfiltered result might look too reddish for your taste, since the household bulbs produce a lower color temperature than the film is balanced for. An 82B filter will bring up the color temperature enough to give you accurate-looking color rendition in this case.

The 81 series filters do just the opposite; they lower the color temperature, letting you overcome the overly blue results you would get with daylight-balanced films if you used them without a filter in open shade or when the skies are overcast. An 81D filter will give just enough "warmth" to overcast scenes to produce more pleasing skin tones in your subjects; a less powerful 81A filter is useful for balancing the output of certain electronic flash units that produce 6000K with the 5500K balance that daylight-type color films are designed for.

To increase the effect of a predominantly cool-toned picture, use an 82 series filter to add more blue, as in the photo at right. A combination of an 82A and 82C filter helps eliminate the reddish light that occurs about two hours after sunrise or before sunset. Photos: D.E. Cox.

Besides providing a way to match the lighting to the color balance of the film, these filters are often used for purposes of expression rather than accuracy to subtly alter the overall warmth or coolness of an image. The most commonly used light-balancing filter for this purpose is the skylight 1A—a very subtle warming filter that is designed to absorb ultraviolet radiation that can give color photographs a slightly cool tinge, especially in landscapes or aerial photographs. Many photographers leave this filter on their lens at all times, to protect the front element from dust or scratches. The filter is so light in hue that it barely affects the exposure time. Certain color films, like Kodak's Ektachromes, are inherently cooler than others. A skylight filter will counteract this coolness quite pleasantly in many instances. To warm up the

USING LIGHT-BALANCING FILTERS

To obtain 3200K from	or	To obtain 3400K from		Use this Filter	and	Increase exposure by (in stops)
3850K		4140K		81EF		⅔
3700K		3970K		81D		⅔
3600K		3850K	Yellowish	81C		⅓
3500K		3740K		81B		⅓
3400K		3630K		81A		⅓
3300K		3510K		81		⅓
3100K		3290K		82		⅓
3000K		3180K		82A		⅓
2900K		3060K		82B		⅔
2800K		2950K	Bluish	82C		⅔
2720K		2870K		82 + 82C		1
2650K		2780K		82A + 82C		1
2570K		2700K		82B + 82C		1⅓
2490K		2610K		82C + 82C		1⅓

results even more, or to augment the overall warmth of certain subjects (red leaves in autumn, for instance), make a series of exposures using 81 A, B, C or D filters over your lens. The letters indicate the degree of warming the filters provide. the 81 A, B and C filters require one-third-stop more exposure than you would need without a filter; the 81D needs two-thirds-stop more. Your Minolta's through-the-lens metering system will automatically compensate for the difference; if you are using the camera's metering system, put the filter on and shoot as indicated. If you are using a hand-held meter, make the necessary adjustment to your lens opening before shooting. In any event, bracket your exposures; you may find that a slightly underexposed rendition of the subject will be more pleasing.

(Top left) — A photo made on daylight film under tungsten light has a yellowish cast. (Top right) — The same photo made on tungsten film in tungsten light has a more normal appearance. (Bottom left) — Filmed in daylight on tungsten film, the photo appears much too blue. Compare with the same photo on daylight film (bottom right).

Color Conversion Filters. If you attempt to make outdoor pictures with film balanced for tungsten illumination, your results will look far too blue—the film is designed to counteract the redness of incandescent light, and will respond more to the blue wavelengths outdoors than to the others. Conversely, using a daylight-balanced film indoors will produce orangey or reddish casts that may be acceptable in some instances, but will look too warm in most. Color conversion filters are designed to let you get more neutral-looking results should you want or need to use films that are used in "incorrect" light. Filters in the 85 series are amber-hued, producing a more or less neutral result when tungsten film is used outdoors or with electronic flash. The most common of the series is the 85B, which requires a two-thirds-stop increase in exposure and gives reasonably accurate subject hues with tungsten-balanced films used in noon sunlight or with electronic flash.

If you want to shoot with daylight film indoors, you will need a bluish 80 series filter. Depending on the light source, you may have to combine it with an 82 series cooling filter for the best results: a 200-watt bulb used as a light source with daylight film can be balanced by combining an 80A and an 82A filter, then increasing the exposure by three stops. The results are rarely as good as they would be if you used a slight cooling filter with tungsten-balanced film in a case like this; and the exposure increase needed for the filters is enough to require

uncomfortably slow shutter speeds, especially if there are people in the picture. In most instances, use daylight film indoors only if you are shooting with electronic flash.

COLOR CONVERSION FILTERS

If you are using this type film	Under these conditions	Use this filter	And increase exposure by
Daylight	Tungsten 3400K	80B	1⅓ stops
	Tungsten 3200K	80A	2 stops
Tungsten Type B (3200K)	Daylight	85B	⅔ stop
	Tungsten 3400K	81A	⅓ stop
Tungsten Type A (3400K)	Daylight	85	⅔ stop
	Tungsten 3200K	82A	⅓ stop

Color Temperature Meters. If you want to be absolutely sure of the color temperature of your light source, you will need a color temperature meter. There are two types of color temperature meter. Two-color meters are capable of measuring the relative distribution of red and blue wavelengths in a light source, and are useful in tungsten lighting. Three-color meters are more expensive, but measure the distribution of red, blue and green wavelengths given off by the light source; they can be used to measure the color makeup of daylight, fluorescent light and various kinds of mixed lighting. The meter should be set for the color balance of the film you are using; it will then assess the makeup of the lighting of your scene and indicate the light-balancing filters needed to produce accurate subject tones.

Some color meters also give readouts suggesting which *color compensating* (CC) filters can be used to make extremely fine adjustments to the light balance. CC filters are available in a wide range of densities, the most useful for color balancing being those in the .05 and .10 range. CC filters are generally sold as extremely thin gels, in the primary colors of red, green and blue, and the secondaries of cyan, magenta and yellow. As their name implies, color compensating filters are used to reduce or augment specific hues in the subject or light source. A cyan CC filter will subtract some red from the scene (red is the "opposite" of cyan), a yellow CC will subtract blue, a magenta filter will subtract green; and vice-versa. To add more of a color, add a CC filter of that color to your lens. Red and yellow CC filters can be used as slight warming filters; blue and cyan CCs will cool down overall subject tones somewhat.

Filters for Black-and-White Photography

Virtually all general-purpose black-and-white films are *panchromatic* —they are more or less equally sensitive to all colors in the visible spectrum. Black-and-white films respond to the amount of light reflected from or given off by the subject, and record it in shades of gray that correspond to the brightness of the various colors of the scene— almost. Panchromatic films are made to be slightly oversensitive to red wavelengths, because the manufacturers have decided that most black-and-white photographs are made outdoors in sunlight. If you happen to be photographing in sunlit conditions at noon or thereabouts, the film's extra red sensitivity will compensate for the large amount of blue light present. This guarantees that blue and red objects of the same degree of brightness will record properly.

However, if the light is high in red content, the heightened red sensitivity of black-and-white films will make reds appear as lighter shades of gray than they ought to. Indoor photographs made under tungsten lighting, or outdoor pictures taken in the early morning or late afternoon, can have slightly distorted gray-tone renditions of subject colors. To counteract this, many photographers use a yellow filter outdoors, and a yellow/green one indoors, when they make black-and-white pictures. The yellow filter used outdoors will counteract some of the high blue content of the light. Indoors, the yellow / green filter will neutralize some of the redness of tungsten light.

The relatively deep-colored filters used in black-and-white photography lighten the appearance of subjects that are the same color as the filter while darkening those subjects whose colors are opposite. Blue skies can be made darker with a yellow filter; darker still with an orange one; and almost black with a red filter. A green filter will lighten the tonal rendition of foliage, while darkening subjects with any appreciable red content.

The deeper the hue of the filter, the more pronounced its effect. The table "Filters for Black-and-White Films in Daylight" will give you some idea of the effects and principal uses of these filters.

Filter Factors. All of the visibly colored filters used in black-and-white photography require some increase in exposure. In many cases, the through-the-lens exposure system of your Minolta SLR will automati-

FILTER FACTOR ADJUSTMENTS			
Factor	Change Exposure	Factor	Change Exposure
1.5	+ ½ stop	7–9	+ 3 stops
2	+ 1 stop	10–13	+ 3 ½ stops
3	+ 1 ½ stop	14–18	+ 4 stops
4	+ 2 stops	20–27	+ 4 ½ stops
5–6	+ 2 ½ stops	30–35	+ 5 stops

FILTERS FOR BLACK-AND-WHITE FILMS IN DAYLIGHT

For this Effect	On this Subject	Use this Filter
Natural	Blue sky	Yellow
Darkened		Deep yellow
Very dramatic		Red
Almost black		Deep red
Night effect		Red plus Polarizer
Natural	Water scenes under blue sky	Yellow
Water dark	Sunsets	Deep yellow
Natural		None, or yellow
Increased brilliance		Deep yellow, or red
Haze emphasized, added	Distant landscapes	Blue
Slight haze added		None
Natural		Yellow
Haze reduced somewhat		Deep yellow
Increased haze reduction		Red, or deep red
Natural	People in close shots, against sky	Yellow-green, yellow, or polarizer
Natural	Flowers—blossoms and foliage	Yellow, or yellow-green
Natural	Green foliage, nearby	Yellow, or yellow-green
Light		Green
Lighter, for detail	Red, rust, orange, and similar colors	Red
Lighter, for detail	Dark blue, purple, and similar colors	Blue
Natural	Light-colored building materials, fabrics, sand, snow, etc., under sunlight and blue sky	Yellow
Increased texture		Deep yellow, or red

cally compensate for the amount of illumination absorbed by the filter; the automatic exposure modes will make the correct decisions. Sometimes, though, very deeply colored red or blue filters might cause errors in exposure if you rely on the camera's metering system directly. To be on the safe side whenever you use deeply colored filters of any kind, make your exposure readings with the filter removed, then adjust the exposure setting according to the filter factor indicated on the filter's rim. The filter factor number indicates *by how many times* you must increase the exposure to compensate for the filter. A filter factor of 2 means you must double your exposure—increase it by 1 stop. A filter factor of 4 calls for a 4-times increase in exposure—an increase of 2 stops.

A green filter was used here to produce a woodsy, unearthly image. The ethereal feeling is enhanced by a thin film of Vaseline spread over the filter — never on the lens itself — to diffuse the highlights in the scene. Photo: R. Farber.

Tinted Filters For Special Effects

There is no law stating that you must use only the filters designed for color photography with your color films. Nor is it written anywhere that you must make all of your photographs through optically perfect filters. Many arresting images are made using such esoteric items as colored candy wrappers, pieces of patterned colored glass and other non-photographic items.

You can get highly unusual, pleasing results from your color films combined with black-and-white filters, provided that you have a good sense of color and appropriate subject matter. Sunsets, for example, can be made more interesting at times if you make your color exposures through a medium yellow or orange filter, instead of one of the light balancing filters normally used with color films. Closeups of fall foliage can be rendered as monochromes through the use of yellow or green filters, without taking anything away from the spirit of the subject.

Tea-colored or sepia filters will let you make monochromatic color pictures that look as if they were made at the turn of the century. Some photographers use this kind of filter with subjects that they have arranged and dressed to appear as though they really were from the late 1800s, but the effect is even more arresting when applied to certain contemporary subjects.

To create a nighttime version of a daylight scene, use a deep blue or violet filter to override the natural colors of the scene. This is especially effective when the sky is clear and the sun is part of the scene. The blue filters used for copying work with black-and-white films will not be strong enough to produce a nighttime effect; you will need an extremely deep filter specifically designed for special effects. Manufacturers such as Cokin offer a wide variety of deeply toned filters. Color compensating (CC) filters (normally used for color printing) can also be used for this kind of picture; a 50-density blue CC filter should be all you need to turn the sun into the moon in your picture.

As stated before, ordinary colored gelatin or cellophane can be used to change the overall color rendition of your film for expressive purposes. This idea works best with subject matter that does not depend on image sharpness to work; a candy wrapper is hardly optically flat, and even though holding it close to the front element of the lens will render the creases completely out of focus and unnoticeable, the sharpness of the image is bound to suffer somewhat.

An amber filter was used to deepen the reddish light of sunset. By not compensating for the filter factor, the photographer deliberately underexposed the scene to achieve the strong silhouette effect of the trees and buildings. Photo: PhotoGraphics.

Diffusion attachments, or "soft-focus" filters, soften the sharp separation of highlights and shadows in a scene, resulting in a misty, romantic effect. These filters are especially popular for photographs of women, where the diffusion hides lines and flaws by softening thé shadows they normally create. Photo: R. Farber.

Special Effect Attachments

Strictly speaking, a filter is an optically flat piece of glass or plastic that absorbs light of a certain wavelength. There are a number of filter-like attachments that can be used to produce a wide array of special effects —some startling, some absurd, others beautiful. One or two of these devices will give you images that evoke a bygone photographic era; others will render the scene in shapes and hues that could not possibly exist except outside this world.

Diffusion attachments. Diffusion attachments, sometimes called "soft-focus" filters, are made of plain glass or plastic with an irregular series of concentric ridges on their surface. As light rays strike the filter, the ridges interfere with the rays' straight passage, causing the sharp separation of highlight and shadow areas of the scene to soften. Highlights become somewhat diffused, giving a romantic, misty appearance to your subjects. This effect is a favorite among photographers who like the soft look of photographic portraits made in the last century; it is equally effective with certain still-life and landscape subjects.

Diffusion attachments are made in a variety of strengths. Heavily backlighted subjects are best photographed with relatively weak diffusion, while front- or sidelighted subjects are more suitable for filters that diffuse the image more severely. No matter how strong the filter is, its effect will increase as you open up your lens. The wider the aperture, the more noticeable the effect.

You can produce a similar effect to that given by a diffusion attachment by using a clear glass or UV filter with a thin piece of nylon mesh stretched across it tightly. For natural-looking effects, use the most neutrally colored fabric you can find; experiment with more strongly colored fabrics for unusual color casts.

Fog and Mist Filters. These attachments produce somewhat softer, less sharp results than diffusion attachments. They are available in continuous and graduated varieties. The continuous ones give your photographs an overall misty appearance similar to that produced naturally by foggy conditions; the graduated type will let you place the mistiness selectively, so that the background will appear more foggy than the foreground, or vice-versa. Both continuous and graduated types come in different strengths.

A fog filter with a purple tint produced the misty landscape shown here. Depending upon the strength of the fog filter used, a variety of effects are possible. Photo: R. Farber.

A heart-shaped masking device was used in a matte box to produce this effect. Masks are available commercially in a variety of shapes; it is also possible to make your own from cutouts on heavy black paper. Photo: M. Fairchild.

Masking and Vignetting Devices. Masking devices are a favorite of wedding photographers; they let you produce photographs that seem to have been shot through a champagne glass, a keyhole, a telescope, or some other item with an easily recognizable outline. Masking devices are used in a bellows-like device called a matte box. One end of the matte box attaches to the front of your lens; the other has a holder for filter gels and variously shaped cutouts such as the ones mentioned. Short-focal-length lenses used at small apertures produce the best results with matte boxes and masking devices.

Vignetting devices are like graduated neutral density filters; they leave the central portion of the lens clear, getting gradually darker towards the edges. Besides the neutral density variety, vignetters can also be had in a wide range of colors. The effect these produce is to leave the natural colors of the scene intact at the center of the picture, while gradually tinting the surrounding areas the color of the filter. Red, yellow and orange vignetting devices can be used with black-and-white films to gradually increase the contrast of tones around the center of the image.

Split Field Attachments. A split field attachment is a little like a bifocal filter; half of it acts as a closeup lens, while the other half is either ordinary glass or missing altogether. Carefully aligning this device with the horizon or other horizontal line of an appropriate subject, then focusing on the distant part of the scene and stopping the lens down will let you produce photographs that look sharp from just in front of the lens to infinity. A little creativity on your part in placing the attachment and choosing your subject will let you produce two distinct areas of sharp focus separated by an out-of-focus area. Done properly, this effect can be quite baffling to the viewers of your pictures, and might produce some interesting images besides.

Color Polarizing Filters. Like conventional polarizing filters, color polarizers have a rotating ring that you move to change the way in which your lens accepts light. However, color polarizers completely change the overall color of the light passing through them. One type of color polarizer will gradually turn a deeper and deeper version of its own color as you rotate the polarizing ring; another type will change its color completely as you rotate the ring. Some of these polarizers change from green to red; others from yellow to blue or green to yellow. These are truly special-effect devices; the results they give rarely have any bearing on the colors of the real world. Because they absorb more light than most other filters, polarizing color filters usually require the use of fast films, although in very bright light, moderate speed films may be used.

Color polarizing filters completely change the color of the light passing through them. Here, a variable-color filter was used to color the reflections of the lights in the water. Photo: D.E. Cox.

Star Filters and Diffraction Attachments. *Spectrum filters* make use of extremely fine diffraction gratings to break up into its component parts light coming from bright highlights in a scene. The result is that extremely bright highlights—reflections from metal, street-lamps and certain glinting glass reflections—will give off halos or sparks of rainbowlike color, the pattern depending on the pattern of the diffraction grating.

Star filters work in a similar way, but give off patterned echoes of the highlight areas without the rainbow effect. Star filters are designed with etched surfaces that break up the highlight reflections. If the surface pattern of the filter is etched in squares, a four-sided star will result. If the etching is squared and diagonal, the star produced will have six or eight points, depending on how many corners each each section of the etched pattern has. The closer the bright light source is to your lens, the more noticeable the effect of these filters will be. You will see the most clearly defined star effect if you stop your lens down to f/5.6 or f/8.

Star filters have crisscrossed lines etched on them, and work by breaking up highlights. The pattern of "stars" depends upon the pattern etched into the filer.

Repeaters, or prism attachments, break up the image into a number of separate versions. The design and placement of the image will vary depending upon the type of attachment used. The most effective subjects are those with clean, undistracting backgrounds. Photo: D.E. Cox.

Repeaters and Prism Attachments. Multi-image prism attachments, sometimes called "repeaters," break up your subjects image into a series of discrete versions of itself, arranged in a horizontal, vertical, diagonal or circular pattern, depending on the attachment's design. The mounts of these attachments rotate, letting you place the series of images in whatever configuration you find most pleasing. These devices work best with graphic subject matter against clean, undistracting backgrounds. Some versions of this device leave the central image in place while the repeated versions can be rotated; others have wedge-shaped sections, all of which rotate as you turn the attachment ring. These devices are among the most popular of all the special-effect attachments, and new versions of them are being introduced on a regular basis. Some of the newer ones, instead of simply repeating the main image a number of times, let you make a straight record of your subject on one half of the frame, while distorting and stretching it on the other. The effect can be quite unusual with the right subject and approach; but keep in mind that a boring subject will be, for example, six times as boring through a six-times repeater.

5

Using Minolta Flash Units

One of the least expensive, easiest and most powerful ways of extending your picturetaking potential is by adding a portable electronic flash unit to your personal system. Besides providing illumination when there is not enough natural light to make pictures by, a portable flash will let you use daylight-type color film indoors, since the kind of light it provides is similar in quality to daylight.

With an electronic flash unit, you can adjust the angle of illumination to suit your pictorial purposes. The direct light from an electronic flash unit aimed directly at the subject provides a strong, direct light that is difficult to achieve any other way; the same flash unit can be used to bounce light from a ceiling or wall, providing pleasantly soft illumination for portraits and other subjects needing gentle lighting.

Electronic flash units give off an extremely bright light of very short duration. Under certain circumstances, the burst of illumination might not last longer than 1/50,000. This "blink" of intense light makes it possible to freeze the motion of extremely fast-moving objects: the flow of liquid into a glass, the movement of bees as they pollinate flowers, the flight of a tennis ball across a court, are all examples of pictures that are made far easier with electronic flash.

There was a time when flash units were relatively bulky and expensive, and required time-consuming calculations for effective use. Modern electronic flash units such as those in the Minolta system are compact, inexpensive and powerful; most have a range of built-in automatic features that do away with the need for any adjustments or calculations short of choosing a lens opening and setting the proper synchronization speed on the camera. The Minolta system has a series of dedicated automatic flash units that even make the appropriate camera settings for you, let you know through the viewfinder when they are ready for use, and inform you that your flash exposure was correct.

Flash photography allows you to make bright, crisp images under lighting conditions that are otherwise less than ideal. This masked performer was photographed with direct, on-camera flash, the simplest type to use. Photo: J. Isaac.

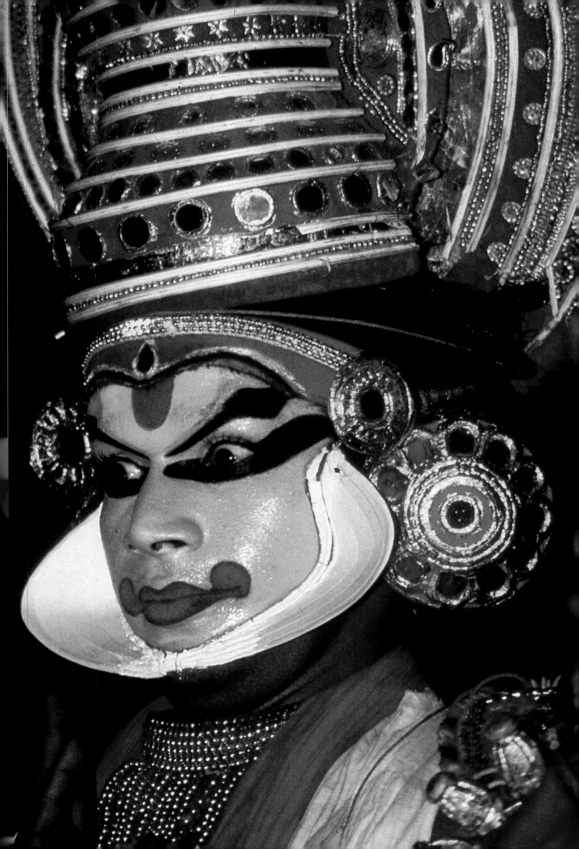

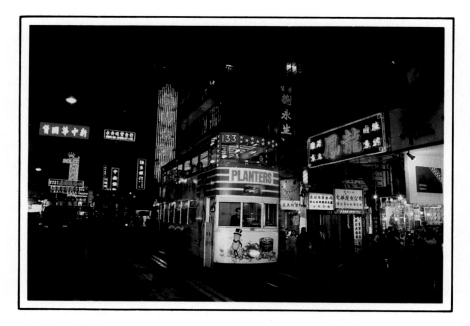

Flash fill is especially useful to illuminate certain parts of a scene at night. Combined with a fast film and the ambient light of the bright street signs, flash fired at a shutter speed of 1/60 sec. or slightly slower was sufficient to illuminate the front of this brightly colored tram passing on a Hong Kong street. Photo: D. E. Cox.

Electronic Flash Explained

An electronic flash unit is essentially a lighting device that produces an extremely short but powerful burst of illumination. The light comes from the action of an electrical charge on a gas stored inside a *flash tube*. The gas responds in the same way that a filament in a lightbulb does; the jolt of electric current it receives causes ignition, lasting no longer than 1/500 sec. or so, and in some instances as little as 1/50,000 sec.

In small, camera-mounted electronic flash units, the power that supplies the current comes from batteries. Most small electronic flash units use AA size batteries, either of the nickel cadmium (NiCad) type, which can be recharged, or the alkaline type, which are slightly more powerful but can only be used once. Neither of these battery types provide enough power on their own to produce the kind of violent reaction needed for the flash to fire; the energy they produce must be stored in a *capacitor,* having first been changed from direct current (d.c.) to alternating current (a.c.) via an oscillator, and fed through a transformer to increase the voltage. Some flash units can be made to

run off the a.c. power supply found in the home; this bypasses the batteries in the flash unit, and does away with the characteristic high-pitched sound you hear when you turn on a battery-operated flash unit (the sound comes from the batteries' d.c. power being converted to a.c.).

The capacitor is the part of an electronic flash unit that actually makes it work; it acts as a sort of warehouse for the energy, hoarding it until enough is stored for proper firing of the flash trigger mechanism. The capacitor is also the most dangerous part of the unit, capable of giving you an incapacitating shock. Do not under *any* circumstances take a flash unit apart; the effects might be fatal.

The flash tube is the part that looks like a small window. Some tubes are surrounded by a silver reflector; others by a gold-colored one. In either case, the light output of an electronic flash unit is balanced to produce 5500K–6000K, which closely approximates the color temperature of daylight at noon. For this reason, electronic flash should be used with daylight-balanced films.

Electronic contacts between the camera's shutter-release button and the flash contact on the camera's accessory shoe or in the flash terminal send a signal to the electronic flash unit's triggering circuit. As you depress the shutter release, the flash will fire in time to illuminate your subject while the shutter is open—but only if you have set the appropriate synchronization speed on the shutter-speed dial. The focal plane shutter in your SLR, because of its design, will not be fully open when the flash goes off unless you have set it to a speed known as the "X" synchronization speed. On Minolta SLRs, this speed is 1/60 sec. Most camera models have an "X" setting on their shutter speed dials. Any speed below 1/60 sec. can be used, but faster speeds will result in partial exposure. Minolta's automatic flash units will key in the correct synch speed when they are attached to the camera's hot shoe.

The power of electronic flash units is expressed in *guide numbers*. The guide number is actually the *f*-stop multiplied by the flash-to-subject distance that will provide an accurate flash exposure:

$$GN = f\text{-number} \times \text{flash-to-subject distance}$$

Each electronic flash unit has its guide number expressed for a specific film speed, usually ISO 100/21°, with the flash-to-subject distance in meters, though sometimes this distance is expressed in feet. By dividing the guide number by the distance your flash unit is from the subject, you can find out what aperture you should set your lens at for proper exposure; conversely, dividing the guide number by the *f*-stop in use will tell you how far away the flash should be. All of these calculations are unlikely to be necessary, though, since all modern electronic flash units have distance/aperture dials on them to do the calculations for you. Automatic flash units go one step further; they control the output of the flash unit to provide just enough illumination for proper exposure, based on the amount of flash light reflecting back to their sensors from your subject.

Manual Flash

Owning a small, light manual flash unit is the least expensive way of guaranteeing yourself enough light to make pictures by, come what may. These pocket-size units are primarily designed for direct, on-camera flash use; most of them have no PC connection cord that would allow them to be used off camera. Although the power of small manual units is substantially lower than that of bigger, automatic flash units, they do provide enough light for moderate apertures with fast films. As emergency sources of illumination, small, manual-only flash units are hard to beat.

Manual flash units are almost ridiculously simple to use. A small dial or table on the back of the unit indicates the aperture you must use, depending on the film speed you are using and on the distance the flash is from your subject. The only other control besides this dial on most units is a small button that lets you fire the flash unit manually. This button usually lights up to tell you when the flash unit is fully charged.

The maximum flash distance range provided by manual-only flash units is usually rather limited, though tiny units such as Minolta's Electroflash 20 will give you properly exposed pictures at $f/4$ with ISO 400/27° film at a distance of about 7.6 meters (25 ft), providing the surroundings are light-colored. Manual electronic flash units seldom have energy-saving circuitry; their recycling times range from about 9 seconds with fresh batteries to 20 seconds or so when the batteries start to die down.

Minolta's Electroflash 20 is a pocket-sized unit designed to be used directly on your camera. A table on the side of the unit tells you what aperture to use depending upon your film speed and flash-to-subject distance.

The fact that these flash units cannot be used off-camera without an adapter causes some problems with color films: eyes are rendered with reddish centers, giving your subjects a vampirelike appearance; and shadows are harsh. You can soften the harshness of the shadows somewhat by placing a layer or two of lens-cleaning tissue in front of the flash lamp. The more tissue you use, the more diffuse the effect of the light, but you will also cut down the light output by about one stop for each layer of tissue. Open up the lens one stop for each layer you use.

Manual electronic flash units will give you properly exposed pictures at distances up to about 7.6 meters (25 ft.) if you use fast film and a large aperture. If the surroundings are dark, it may be necessary to open up the lens 1 or 1½ stops beyond the recommendation on the dial. Photo: M. Fairchild.

Since manual units have no sensor to determine if enough light has reached the subject, you will have to interpret the scene for yourself. In most cases, the aperture suggestions on the flash unit are based on light-colored surroundings. In dark rooms or at night, open up the lens one-half or one stop beyond the recommendation on the dial. If you are using the flash unit at its furthest recommended distance in these conditions, open up a half-stop more.

Automatic and Dedicated Flash

Automatic flash units allow you to work at a variety of flash-to-subject distances at the same aperture. Unlike manual units, which produce a specific amount of illumination every time they fire, automatic units have a variable flash output. A small sensor, acting very much like a reflected-light meter, is built into each automatic flash unit. This sensor is coupled to the film-speed setting dial on the flash; it reads the amount of electronic flash light bouncing back at it from the subject, and immediately cuts off the flash tube's output when it "senses" that enough light has been given off by the flash for proper exposure.

Most modern automatic flash units use devices known as *thyristors* in their circuitry. Thyristors automatically recycle the unused portion of the flash illumination, and store it for the following flash. This reduces recycling times considerably; older automatic electronic flash units without energy-saving thyristors would dump the unused portions of the flash illumination, recharging from scratch with each use. Besides shortening recycling times, thyristor circuitry also prolongs battery life.

Many automatic flash units give you a choice of lens openings to work with within a specific range of distances. (For example, the Minolta Auto Electroflash 320 gives a choice of three apertures in its auto modes, along with manual operation.) The apertures you can use depend on the film speed; each aperture will allow automatically correct flash exposure over a different range. The distances covered properly at each aperture are usually color-coded on the flash unit's indicator dial, so you can quickly see whether or not the aperture you have chosen will provide adequate flash exposure at your flash-to-subject distance. The widest aperture of those available will provide adequate

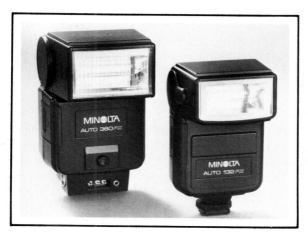

Among Minolta's many dedicated flash units are the Auto Electroflash 360 PX (left) and the Auto Electroflash 132 PX (right), both tailored to the X-700 and X-570. These multi-mode, clip-on units are equipped for automatic and manual flash, multiple flash, bounce flash, auto time-lapse flash, and a variety of other creative flash techniques on or off camera.

exposure over the longest distance; the smallest allowable aperture will provide more depth of field, but at a shorter maximum flash-to-subject distance.

On many automatic flash units, a small "confidence" lamp will glow once the flash has fired, to let you know that your subject was at the proper distance for the lens opening you were using. All of the lens openings will provide accurate flash exposure at the near range of the automatic flash operation; closer than that will cause overexposure, because the flash bouncing back at the sensor will get there too quickly for the sensor to respond in time.

Using an automatic electronic flash unit is simplicity itself: in most cases, all you need do is set the correct film speed on the flash calculator dial; look at the dial's indicators to see what *f*-stops can be used for automatic operation; check to make sure that your subject is within the correct flash-to-subject range; set the *f*-stop, and shoot. Remember, though, that the flash sensor is going to respond to the light in much the same way that a conventional light meter will; if your subject is inordinately light or dark, you will have to make changes in your aperture setting. In effect, you have to interpret the light reading provided by the flash sensor to guarantee the proper tonal rendition of your flash subject.

Dedicated Flash Units. Dedicated flash units are those that are electronically mated to specific camera types. Special contacts in the camera's flash shoe connect with their counterparts in the foot of the flash unit to provide a number of automatic functions not possible with ordinary automatic flash units.

All of Minolta's "X" series Auto Electroflashes will key in the correct synchronization speed with Minolta automatic cameras; the Auto Electroflash 280PX will provide an appropriate aperture automatically as well, when used with the X-700 camera in its programmed mode. With this combination, you just clip on the flash unit, set the appropriate film speed and shoot. Flash metering takes place at the film plane inside the camera; by using an accessory off-camera shoe and cable, you can get perfectly exposed automatic flash pictures no matter how you aim the flash unit.

Besides providing accurate exposures and the correct synchronization speed, dedicated units provide various indicators in the viewfinder, telling you when the flash is fully charged and signaling that your subject is at the correct distance for accurate exposure.

Many automatic and dedicated flash units have swiveling and tilting heads that allow you to bounce the flash output from ceilings, walls or umbrellas to soften the effect of the light. These "bounce" units generally have their sensors built into a nonmovable part of the unit, so that they can read the light reflecting back towards the camera even if the flash head is not facing the subject directly. Some units have removable sensors that allow you to make accurate flash exposures even if the flash unit is positioned some distance away from the camera.

For the soft shadows in this photograph, two flash units were used. One flash unit, to the right of the picture, was fired through a diffusion screen. The second unit was aimed toward the ceiling for bounce light. Photo: D. E. Cox.

Off-Camera and Multi-Unit Flash

Off-camera use of electronic flash units allows you to model your subject in various ways that are impossible with the flash unit attached to the camera's hot shoe. For example, you can completely change the appearance and mood of your direct flash pictures by aiming the flash unit at your subject from above your head and over to one side, or from underneath. In the first instance, you will create deeper, longer shadows on one side of your subject's features; with a little practice you will be able to produce far more pleasing results than on-camera flash would give. In the second case, the shadows will be cast upwards, giving your sitter an eerie, dramatic appearance. Electronic flash, both manual and automatic, can be used in exactly the same way as you would use ordinary room lamps in an available-light situation to get the best possible blend of subject and shadow. With the appropriate clamps and extension cords, almost any flash unit can be placed on a lightstand or held far away from the camera.

Remember to base your aperture on the total distance from flash to subject, ignoring the location of your camera. If you are bouncing the flash, allow for the bounce and for the slight light-absorbing qualities of the surface you are bouncing from. If you are using the flash unit on automatic, make sure that the auto system range covers the total

flash-to-subject distance; also, make certain that the flash sensor is aimed at your subject from the camera position.

Multiple Flash. There may be times when one flash unit is not enough to properly light your picture. Multiple flash photography is easy and convenient; you can, for all intents and purposes, carry an entire lighting studio in one small gadget bag if you equip yourself with a main flash unit and a couple of others to which you have attached *slave switches.*

Most slave switches are small photoelectric triggers that will fire the flash units they are attached to as soon as they sense the output of another flash unit; the slaves have wide angles of acceptance, so you can position them just about anywhere and have them go off as soon as your main flash is fired.

The main advantage of slave units is that there are no extension cords to get in the way; as long as the sensors are in line of sight of the main flash, and as long as the main flash is not too far away to fire the farthest slave flash unit, the scene can remain uncluttered with leads and cords.

Slave switches have one drawback: they are expensive when compared to extension cords and multiple flash connectors. If you need multiple flash and cannot afford a series of slave switches, you may have to use extension PC cords. Be careful, though—some cameras cannot handle the electronic load of having to fire more than one flash unit at a time. The added expense of slave switches is balanced out somewhat by the fact they do away with the need for physical connections between one flash unit and another.

There are various methods to determine proper exposure with multiple flash. Begin by using all of the flash units in their manual mode; then set the aperture needed for the distance between the main flash and the subject. Use this setting if the other, supporting lights are at more than a 90-degree angle to the main one. If they are closer, at less of an angle, shoot at an aperture one-half to one stop smaller than the aperture required for the main light.

Do not try to mix automatic units with manual ones for multi-unit flash lighting; the sensors of the units will not read the light properly.

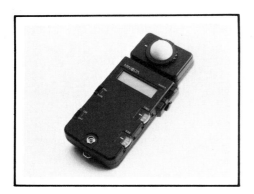

For absolute accuracy in determining the correct aperture in this and any other kind of electronic flash photography, nothing can compare with a good electronic-flash meter. Flash meters look like ordinary incident-light meters, but they are specially calibrated and designed to respond to the short bursts of illumination given off by electronic flash.

Bounce Flash

You can soften up the harsh quality of electronic flash illumination in a number of ways; one of the most pleasing and versatile is to bounce the illumination from a neutral-colored ceiling, wall or reflector. This will make shadows far less harsh, and will spill the flash illumination over a broader area, causing a more diffuse light quality overall. Many photographers routinely carry a small white flash umbrella with them, and aim their flash heads into the umbrella, which is tilted so that it sends the flash illumination onto the subject. Bouncing flash light reduces the intensity of the illumination somewhat, but produces far more pleasant lighting for most subjects.

Many automatic flash units have built-in bounce features: their flash heads can be turned or tilted towards any appropriate bounce surface, while their flash exposure sensors stay in line with the subject. For times when no wall is convenient, or the surroundings are too strongly colored or dark, a small white card can be attached at an angle to the flash head; with the head pointing directly upwards, the card acts as a mini-ceiling, spilling diffuse light onto your subject. These cards can be brought to fit most flash units, but they are so easy to make (all you need is some heavy white stock or matte-finish white plastic and a rubber band) that buying a ready-made one seems a bit wasteful.

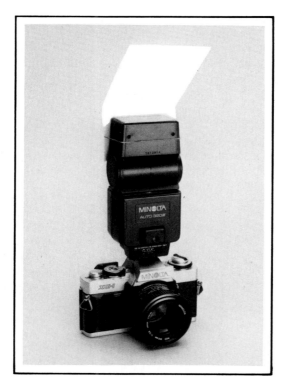

To use bounce flash when there is no appropriately colored wall or ceiling, mount a white card on the flash unit with a rubber band, as shown here. The card acts as a bounce surface.

Automatic bounce flash is simple, since the sensor does most of the work for you. Keep in mind, though, that it is the *flash-to-subject* distance, not the camera-to-subject distance that counts; if the bounce surface is far enough away, you may have to use the largest automatic flash aperture available. Keep an eye on your flash distance indicator, just to be on the safe side.

For manual bounce flash, do the following:

1. Measure the total distance of travel for the flash illumination (flash-to-ceiling/wall-to-subject);
2. Look on the flash unit's distance scale for the aperture needed at the distance you just calculated;
3. Open up the lens by one stop for a white reflective surface; 1½ stops for a warm-white or cream surface.

Unless you want color casts for some specific reason, do not bounce flash from colored walls, draperies or other surfaces when using color film. Even pale yellow or pale green surfaces will affect the flash illumination enough to cause a color cast. Use the white reflector card or small umbrella mentioned earlier, or improvise a bounce surface by using a white shirt, towel or other handy piece of white material.

Bounce flash was used to brighten this birthday scene. Two bounce surfaces were used. The flash was aimed at the ceiling, bouncing from there to a white card positioned as a deflector at the left of the frame to illuminate the child both from above and on her face. Photo: D. E. Cox.

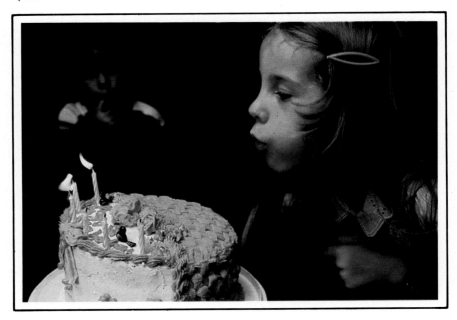

6

Topics and Techniques

Think back for a moment to the first few weeks you spent as a photographer. Like most people using a camera for the first time, you probably made pictures of everything in sight, excited by the fresh way your viewfinder showed you the world. You made mistakes along the way, becoming disappointed because what you saw in your subjects somehow managed to elude your prints or transparencies.

As time went on, your knowledge of camera, lens, film and their efficient use improved. The mistakes became less frequent, leaving you more energy to refine the range of topics you wanted to make pictures of. You began to spend more time on specific subjects such as landscapes, on photographing your children, or kids in general, on trying to record the peak moments of your favorite sporting events, on making portraits of friends or interesting acquaintances, on picturing the way your neighborhood changes as the sun goes down, and so on.

As you turn your attention to one or two kinds of subject more than any other, you may find that your pictures occasionally fail, even though you made what you thought were the correct technical decisions. For example, your night scenes might be underexposed even though you followed your meter's recommendations; your portraits might show facial distortion that did not seem to be there as you looked though the camera; your sports pictures might just miss capturing the excitement of the game. In cases like these, a slight change in your tools, timing or approach, along with a knowledge of how your materials behave under certain conditions, will help you produce stronger photographs.

The following sections outline various tools for specific picturemaking situations; there are also suggestions about the techniques necessary for their successful use. In addition, the sections might give you a new idea or two about photographic subjects you may not have though of, or thought impossible with the equipment you own.

Sunsets are a favorite time of day for seascape photographers. If desired, the reddish color of the light can be enhanced by use of a tinted filter; or you may prefer the more subtle, pastel effects of the natural colors, as shown here. Further information on landscape photography appears later in this chapter. Photo: J. Isaac.

Portraiture

What is the difference between a picture of a person and a portrait? Both show the subject's physical features, the clothes he or she wears, and so on. In both kinds of picture we get a sense of the subject's physical makeup. But a true portrait goes deeper, showing something about the *internal* makeup of the person portrayed.

To make a successful portrait you must first understand your potential subject's character, and in what ways that character shows itself. Does the person have a special way of smiling, tilting the head, sitting or standing? Is he or she particularly shy? Should you include some of the sitter's workplace or home to make your portrait stronger? These and other such factors help determine how you should approach your subject, where to shoot and what equipment you will need.

A portrait is a *careful* observation of someone. When we observe something with care, we tend to disregard the things around it, so in many cases a portrait works best when extraneous backgrounds are subdued. An easy way to do this is to keep them out of focus. Short telephoto lenses in the 85–100mm range give shallow enough depth of field at large apertures to keep backgrounds from interfering. These lenses provide a comfortable shooting distance as well, letting you fill the frame with your sitter's head and shoulders from about 2.7m (9 ft) away. At this distance you will avoid the distortion you might get with a normal lens used close enough to make the same kind of picture.

A short telephoto lens will allow you to make very tight head shots without distorting the features of your subject, and will also let your work at a distance that is comfortable for both photographer and sitter. Photo: L. Jones.

Soft-focus effects are popular for portraits of women. In addition to providing a misty, romantic feeling, the soft focus look also disguises lines and other facial imperfections. Minolta's Varisoft lens is ideal for this effect; you can also use a soft-focus filter or even a layer of fine nylon mesh. Photo: J. Tomaselli.

Zoom lenses in the 35–70mm and 50–135mm ranges are also ideal, giving constantly variable focal lengths in the most useful range for portraiture. Special-purpose lenses such as Minolta's 85mm Varisoft, lets you dial in varying degrees of spherical aberration ("optical softness") for a romantic "soft-but-sharp" look you cannot get with soft-focus filters. The effect can be dialed out altogether for normal work.

Keep your lighting as simple as you can. Many portraitists prefer the subtle, even light of the sun on slightly overcast days. Tungsten light or flash bounced from a ceiling or into a reflector placed above and a bit to one side of the subject will give a similar effect. A piece of white board or cloth will help you modify the dark areas on the shadow side of your subject. Move the reflector back and forth until you get the degree of shadow lightening you are after. You can do the same thing indoors with a lamp instead of a reflector. In any event, for a natural-looking portrait, keep the highlight and shadow renditions within 1½ stops of each other for color, within 2–3 stops for black-and-white. Greater contrast between dark and light areas will give a stark, dramatic effect—one that might work well if your subject has an appropriately dramatic appearance or disposition.

Above all, keep your sitter at ease. Use your equipment without fumbling; discuss things of mutual interest, and do not disappear behind the camera for too long—keep eye contact with your subject as often as possible.

Photographing Children

Children—your own, or just kids in general—are an ever-changing, constantly rewarding source of photographs, requiring little in the way of equipment. The most important tool you need to successfully photograph children is an appreciation of what makes them special: their fresh, open way of looking at the world; their uninhibited sense of fun and play; their ability to be very serious one moment and completely giggly the next—these and many other attributes, that we as adults have learned to keep in check or have forgotten altogether, are exhibited by children all of the time, and make for telling, meaningful pictures.

Before you decide on what film and lenses to use for your pictures of kids, study your subjects. Observe children of various ages at play, with one another or alone. Try to get a sense of how they see the world and respond to the everyday things in it; you might be surprised at how a little research of this type can remind you more strongly what it is

Try photographing children from their own level — somewhat closer to the ground than for an adult. This will give you a somewhat better idea of how a child perceives the world, and will help you to interpret his or her activities with greater fluency and sensitivity. Photo: S. Szasz.

Children in all societies exhibit a special enthusiasm and total involvement in whatever activities they are engaged in. In group scenes like this, try concentrating on a individual child for some of your shots. Photo: D. E. Cox.

to be a child. To further understand how children perceive their environment, get a little closer to the ground than normal and look through your camera, with normal lens attached. Pay attention to how long, on average, kids of various ages can keep their minds on different events and pastimes; the mental notes you make while doing this will help you know how to approach your picturemaking of various age groups.

Once you have researched the behavior of your young subjects a little, you can select the tools you will need for making pictures of them. Do you want photographs of one or two young kids at play, while keeping yourself at a comfortable shooting distance so as not to disturb them? Choose a short, easily handheld telephoto lens and some fast film, so that you can freeze motion and move around without needing a tripod. Lenses in the 85mm to 135mm range are ideal for this kind of picture, as well as for informal portraits. For more formal portraiture, use slow films for better image quality and color saturation. An 85mm or 100mm lens will eliminate the perspective distortion a shorter lens might give if you made head-and-shoulder portraits with it.

If you want pictures of larger groups of children, try a slightly wide angle lens—a 35mm optic will let you follow the action quickly, and give you enough depth of field to compensate for any slight errors in focus you might make while moving around and shooting.

Whatever kind of picture you are after, stay alert; *the* picture might present itself and disappear as quickly as it does in a sporting event, only with less predictability.

If you are making pictures with the childrens' knowledge, work confidently. Any fumbling with lenses or exposure settings on your

Children's sports require the same understanding of the game required for photographing adult sports events, and can provide you with just as much fast action. Because you can move in fairly close at children's sporting events, it is easy to capture the facial expressions that give a real feeling for the excitement of the game. Photo: P. Bereswill.

It is more difficult to control the activities of children than of adult models. Even when you have them more or less posed, you must constantly stay alert; the perfect picture might present itself and disappear as quickly as it does in a sporting event, only with less predictability. Photo: S. Szasz.

part is bound to make your youthful subjects lose interest. Your automatic Minolta with a moderate zoom lens is an ideal combination for child photography: the zoom will eliminate the need for lens changing, while the automatic exposure mode will let you concentrate on the scene without worrying unduly about exposure settings.

If the child is curious about your camera, answer any questions in a way the kid will understand. You may just instill an interest in photography in the youngster.

Your photography of children need not be limited to impromptu snapshots or portraits; try such things as recording the events that occur to a child throughout his or her typical day; or record the growth of your kids by making a photograph at the same time each year—on birthdays, for example. The resulting record will be a valuable family document, both for you and your subject.

For more information about the techniques and tools of photographing children, look at the Modern Photo Guide entitled *Basic Child Photography*.

Architectural Photography

Architectural photography is photography of form; the textures, lines and shapes of buildings, bridges and other structures are all fascinating subject matter, and can be easily captured with your Minolta SLR.

Perspective Control Lenses. Much professional architectural photography is done with large-format view cameras; not only because of the high image quality provided by large film sizes, but also because view cameras allow the lens to be positioned in such a way as to reduce or eliminate distortion, converging lines, and other elements that might detract from the strength of the photograph. More and more, though, the 35mm camera is being used, mainly because of the introduction of a new lens type—the *perspective control* lens. This lens type has a front section that can be moved up, down or laterally, to allow the inclusion of the tops or sides of buildings without needing to tilt the camera. By moving the PC lens's front section, you change the relationship between its optical center, or axis, and the film. Moving the axis upwards will let you include far more than you could by raising the entire camera upwards; in most cases, this will let you get the roofs of buildings in the picture while keeping the camera parallel to the building's walls—a must if you want to avoid converging lines.

The same shift control, used laterally, seemingly performs magic: it will let you literally "shoot around" obstructions in front of your lens. Imagine that you want to make a picture of a storefront, but there is a light pole in the way, right at the center of the scene. You cannot move closer to shoot in front of the pole, because that will cause you to lose the edges of the storefront. If you tried to make the picture from an angle to one side of the pole, the storefront would appear "keystoned"—its far side would be further away from your lens, and would appear smaller in the picture. Solution? Move your camera slightly to one side of the pole, then use the perspective control of the lens to move its front elements back in the direction you just moved the camera from. In many cases, this will let you eliminate obstructions like the one described; the controls can also be used to "remove" automobiles and other distractions from the edges of your pictures.

For the photographer whose subjects are predominantly architectural, the perspective control lens is all but a necessity. Even so, many architectural scenes require no more than a moderate wide-angle lens, some high-resolution film, and a carefully chosen time of day in which to shoot.

Angle of Light. If you are interested in making pictures of a specific building or area, examine it in various kinds of light. Get up very early, to see what it looks like just after dawn or in the early morning hours, when the light is soft and the shadows at an interesting angle. Return to the scene in the afternoon; the shadows will be modeling different

In order to include the tops of tall buildings in photographs taken with conventional lenses, it is necessary to tip the camera back so the filmplane is no longer parallel with the subject. The resulting photograph (top) exhibits the converging lines characteristic of this situation. The PC lens allows you to move its axis, or optical center, upward without tilting the camera backward; by keeping the filmplane parallel to the buildings, you will avoid the converging lines, as the bottom photo demonstrates.

facets of the structure, and may give it a completely different appearance. The worst time of day to make architectural pictures is usually at noon, when the light is harsh and the shadows cast straight down, making even the most dynamic structure lose much of its visual strength. Choose a clear day to make your pictures—preferably one with white clouds in the sky. Use the slowest film the light will allow, and make sure to keep your camera mounted on a tripod. If you are shooting with black-and-white films, a deep yellow or orange filter will bring out the clouds by darkening the blue of the sky—adding drama to the picture. For an even more theatrical effect, use a red filter—but only if the building deserves this kind of overstatement. A suburban split-level ranch house would look a bit pretentious against a black sky. For color films, use a polarizing filter to deepen the blue of the sky without affecting the other colors in the scene.

Telephoto lenses are also useful in architectural photography; a 200mm or 300mm lens will let you pick out interesting details from otherwise inaccessible sections of buildings.

Photographing at Night

Far too many photographers put away their cameras when the sun goes down; they assume that photography is to be done in the daytime, or indoors under artificial lighting. The adventurous minority have discovered that nothing could be further from the truth. A fascinating world of nighttime subject matter awaits anyone with some fast film and a lens with a maximum aperture of $f/2.8$ or larger.

Familiar outdoor surroundings take on a new mood at night; not just because the overall light is low, causing the shapes of buildings and trees to take on added graphic strength, but because most people out on the streets are at ease, on their way to relax after a day of work. The pace is slower; the traffic lights lend an almost festive air to the environment. Automobile lights, storefront illumination and streetlights combine to produce a mosaic of color and brightness that is photographically interesting in itself, and often more than adequate for picturetaking. The places where people are likely to congregate are usually well lighted. Some storefronts and movie houses give off enough light to let you shoot your ISO $400/27°$ film at $1/125$ sec.!

Fireworks can be photographed only at night, and the technique is relatively simple. With the camera mounted on a tripod or other sturdy support, set the focusing scale on infinity. With ASA 400 film, set the aperture at f/16 or f/22 (with slower films, use appropriately larger apertures). Set the shutter on the "B" setting and open the shutter for the duration of one or several bursts. Photo: D. E. Cox.

Take a walk around your town after the sun sets, keeping a photographic eye open to the picture-making possibilities that exist. You may be surprised at how quiet and powerful the shapes of buildings in normally busy downtown areas look; at how the darkness sets off the architectural details of municipal sculptures, fountains and other public monuments. You will see flashes of color from posters and advertisements that are partially lighted by streetlamps; peoples' faces are set off brightly by the light from passing cars or from indoor light as they enter and leave their houses or restaurants. With a little care in focusing and exposure, all of these things can be used to make expressive pictures of the night.

Keeping the Camera Steady. Unless you plan to photograph exclusively by the light coming from brightly lighted shops or theatres, you will need a camera support of some kind. A full-sized tripod is best, especially if you are interested in photographing buildings or other structures; but if you want more mobility and would rather not attract too much attention to yourself, a folding monopod or tabletop tripod will do just as good a job as a large tripod in many cases—and a better one in some others. The tabletop tripod is an extremely compact, sturdy device that can fit into any gadget bag; it is quickly assembled and will let you support your camera against any convenient wall, car roof or mailbox with ease. In a pinch, the tabletop tripod serves as a chest support; it is just tall enough to bring the camera's eyepiece to your eye while supporting the weight of your camera on your chest.

In an emergency, you can keep your camera steadier by tightening the shoulder strap and hooking your thumbs through it as you hold the camera to your eye. Adjust it until you can bring your camera tightly against your forehead, take a deep breath, let half of it out slowly, then gently release the shutter. With a little practice, this technique will let you shoot at surprisingly slow speeds.

Using Color Films. If you make your pictures on color transparency film, keep in mind that most nighttime illumination is of the tungsten variety. For a neutral rendition of night illumination, shoot with a tungsten-balanced film; daylight-balanced films will give you warmish results. Color negative films are easier to use, since color casts can be filtered out during printing. ISO 400/27° color films like Ektachrome 400 (positive) and Kodacolor 400 (negative) are ideal for nighttime use; their relatively large granularity and soft color rendition, as compared with slower color films, augment the night mood in many cases. Kodak has recently introduced a color negative film with an astonishing speed of 150 1000/31° which makes color photographs possible in light you would have trouble seeing by.

Using Black-and-White Films. Black and white films such as Agfapan Professional 400, Ilford HP 5 and Kodak Tri-X will let you shoot in all but the darkest situations. For really dim light, there are films like Kodak Recording Film and Agfa Isopan Record, which give exposure indexes of up to 1600, depending on the way they are processed. These extremely fast films have very little in the way of resolving power, but their large grain structure provides an impressionistic result that can be quite compelling.

Slow- and Medium-Speed Films. Slow- and medium-speed films can also be used at night, for static subjects; but they will usually call for exposures longer than 1 sec. This brings into play something called *reciprocity law failure.* In short, reciprocity law failure has to do with the fact that most films become relatively less responsive to light at extremely long exposure times—so in order to get the correct exposure you will have to expose longer than your meter tells you to. The table in this section will give you a general guide as to how much you will need to change your exposure and developing times.

RECIPROCITY FAILURE COMPENSATIONS FOR BLACK-AND-WHITE FILM

If your meter indicates this exposure time	Increase your aperture by	OR	Increase your exposure time	in either case	Decrease development time by
1 sec.	———		1 sec.		———
2 sec.	1 stop		4 sec.		10%
5 sec.	1 ½ stops		12–13 sec.		20%
10 sec.	2 stops		40 sec.		20%
100 sec.	3 stops		13 ½ min.		30–40%

Note: The adjusted exposure compensations suggested here are bare minimum changes. Since extra-long exposures build up more resistance to the effect of light on the film, even longer exposure times may be required.

Color films shot at extremely long exposure times have an added problem: their colors will shift, sometimes unpredictably. The effect you get will rarely look like the scene does to your eye, but might be quite beautiful in spite of that. Many film manufacturers recommend filters that will help keep the colors of the scene from going too awry.

To keep your long color exposures as neutral toned as possible, use a type "L" color negative film. Type "L" films are specially designed to resist reciprocity law failure, and are usually balanced for tungsten lighting.

If you find yourself shooting at night often, expand you capabilities with a fast lens such as with a maximum aperture of $f/1.2$ or $f/2$. If you alread own an $f/1.4$ lens, you may not need the extra half-stop or so given by the $f/1.2$ lens; but if you now have an $f/2$ normal lens, an $f/1.2$ lens will give you 1 1/2 stops more to work with. Fast lenses have the added advantage of providing a brighter focusing image.

Another useful nighttime accessory is a good light meter. Minolta's Autometer III is a good choice, being sensitive enough to provide readings in any light that you can see by. Use the meter for closeup readings of important subject tones whenever possible, then transfer the settings indicated to the manual exposure controls of your SLR—but remember to add enough time to counteract the reciprocity law failure effect.

Large, brightly lighted scenes are not the only subjects for nighttime photography. These elegantly detailed streetlamps silhouetted against the sky make an excellent—and stationary—subject. It is frequently difficult to predict how the color of the lights themselves will appear on the film, since it is not always possible to know the exact makeup of the illuminating source. Photo: D.E. Cox.

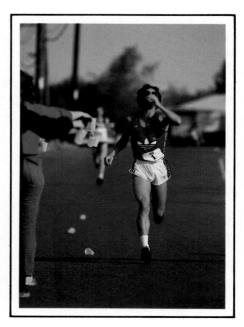

Zone focusing is a useful technique for action photography, where there is often little time to focus for each individual picture. To use the technique, estimate where the action will take place and set the focusing scale and aperture so that the depth of field will be great enough to keep the main subject sharp within your chosen range of focus. When the subject enters that range, take your picture. Photo: P. Bereswill.

Sports Photography

Successful sports photographs are often pictures of peak moments. Fingers outstretched for a touchdown pass; the extended body of a tennis server; the pole-vaulter at the top of his or her arc, are all examples of these moments. All of them have one thing in common— the movement of the athlete comes to a momentary halt at peak times. In most cases, this momentary halt contains all of the dynamism and drama of the event; with quick reflexes and the proper equipment, you can capture these moments and the thrill of the sport through them.

The most important "equipment" you need to make good sports pictures is an understanding of the event you are photographing. Knowing not only the rules but the concepts of the event you are recording will help you anticipate the picturemaking opportunities better.

Lenses. Fast films and large lens openings are the norm for making pictures of action sports such as football, hockey and boxing. In many cases, these events will also call for the use of telephoto lenses, since you will not be allowed too near the field of play. Even if you are at the sidelines of the stadium, you will usually need a moderate telephoto to record action taking place in the middle of the playing field. Zoom lenses in the 75–150mm range are ideal for recording many team sports, since they are compact enough to be hand-held at fast shutter

speeds, and they give you the freedom to make establishing shots and closeups without stopping to change lenses. Longer zooms are more bulky, requiring the constant use of a tripod or monopod; but they will let you pick out individual faces and actions from far downfield. Minolta's 100–500mm f/8 MD Zoom is an excellent lens for this kind of sports photography.

Motor Drives and Winders. Motor winders and motor drives are extremely useful in sports photography, especially when the action is fast-paced and unpredictable. Sometimes a sequence of pictures will illustrate the action better than a single photograph would; for example, a group of photographs showing the windup, impact and aftermath of a well-placed left hook might give your viewers a better idea of boxing than one picture of the blow might. If you do choose to use a motorized film advance, keep in mind that you still have to choose the moment of exposure yourself. If at all possible, use the winder or motor on its single-frame setting, pressing the shutter release button at the appropriate moments. Otherwise, you might end up with a series of pictures none of which capture the meaningful moments. Even if you are not using a winder or motor, try to anticipate the action and begin to release your shutter just *before* the peak moment.

Long lenses are almost essential for most sports photographs, since it is usually impossible to position yourself very close to the action. A good understanding of the sport is also essential: you must be able to predict the action before it occurs. If you can see in your finder the action you want to record, you have missed your shot. Photo: P. Bereswill.

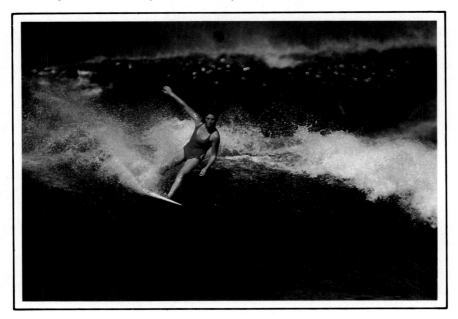

Landscapes and Seascapes

Landscape and seascape photography deals with the broad vistas of the natural scene, in much the same way that nature photography records the specifics of nature. Most of your land- and seascapes can be done with your Minolta SLR and three lenses: a wide-angle (28 or 35mm) lens, a normal lens, and a moderate telephoto to bring distant areas closer. Slow, sharp films are the mainstay of landscape pictures, since they are usually about the physical attributes of the scene. For black-and-white pictures, use a film like Agfapan 25 Professional, Kodak Panatomic-X, or Ilford Pan F—unless the light is especially harsh and contrasty, in which case a medium-speed film like Plus-X would be a better choice. For color transparencies, use Kodachrome 25 or 64, or

Bare branches of a forested hillside in winter appear soft and featherry, giving a hazy effect to this snowy landscape. An overcast sky diffuses harsh shadows and gives this picture its soft blue tone, cooling the scene but not entirely overpowering the warmer white of the branches. Photo: P. Eastway.

any other fine-grained, richly saturated color film. The same holds true for color negative films; your best results will in most cases come from the slowest film you can use in the lighting available.

Most landscapes and seascapes change drastically in appearance as the day progresses. At daybreak and shortly thereafter, the light is soft and warm; to preserve its appearance, shoot your daylight color film with no filters. If you want to remove some of the warmth, use a slight cooling filter; an 80C (bluish) filter will tone down the redness of the scene enough in most cases. If you want completely neutral results in this light, try shooting with tungsten-balanced film instead. The added blue rendition of the film will counteract almost all of the scene's warmth. In any event, most landscapes made just after sunrise look their best if the light is rendered red, just as it normally appears.

At midday, the light is rarely pleasing. Shadows are generally cast straight down, giving most scenics a flat appearance. Wait until the afternoon, when the shadows slant more and give the various aspects of the scene more modeling.

If you are shooting in black-and-white, use a yellow filter to bring out white clouds against a blue sky; a green or yellow-green one to lighten foliage. If the light is especially hazy, use a UV filter to cut through it. The yellow filter will also go a long way in cutting through the haze.

Be careful not to include too much sky in the frame when you make your meter readings. For absolutely accurate exposure readings of important subject areas, use a spot meter.

Sunsets are a favorite of many land- and seascape photographers. The light is extremely reddish at sunset, and can be made to appear even more so on color daylight film with the appropriate tinted filter. These are available in varying shades of "tea" color or tan, as well as in purplish reds. For an unusual effect, try a deep blue filter with your color film—the result will look like a "moonset."

Keep your equipment to a minimum as you walk around in search of your landscape pictures. Distribute film, filters and other necessities into pockets of a parka or field jacket, instead of a camera bag. The heaviest piece of equipment you should carry should be a sturdy tripod.

One small, light device you might find handy is a panorama head. This attaches between your camera and tripod, providing a sturdy support that can be swiveled in predetermined increments, clicking into position at each setting. The positions are varied, depending on the focal length of your lens. The device will let you make a series of pictures that overlap at their edges; you can then combine the photographs to produce a wide, undistorted panoramic view of the scene.

For pictures near the sea, protect your camera from the ravages of salt spray with a polyethylene "camera glove." These inexpensive devices keep the salt and moisture out while allowing you free access to all of the camera's controls. The few dollars you pay for one of these will be more than compensated for by the increased peace of mind it will give you.

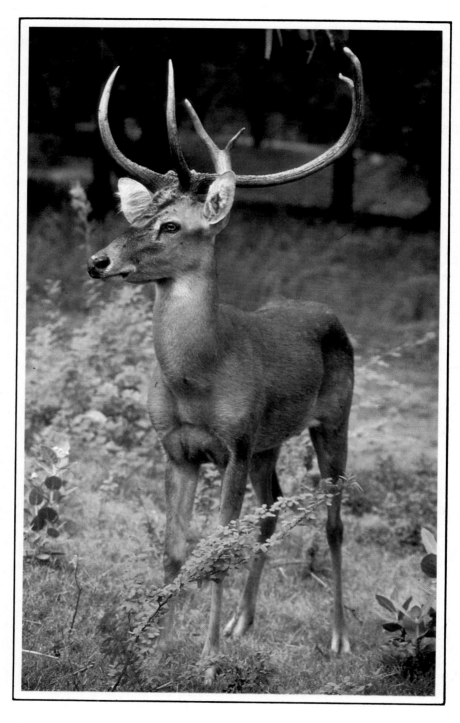

A moderate telephoto lens in the 200 – 300mm range will let you stay far enough away so as not to frighten off your subjects. Patience is the main ingredient of successful animal photography: it may take hours of waiting for your subject to appear. Photo: J. Isaac.

Nature Photography

Nature photography differs from landscape photography by concentrating on the particular aspects of a natural environment. The flowers, plants and animals of any locale, and the way these aspects interrelate, are all raw material for nature pictures.

You do not have to live near a national park or game preserve to make effective pictures of nature; your own backyard might supply you with enough subject matter to keep you busy for quite some time. Even the most urban of areas has at least one park, populated with a surprising variety of plants and animals.

Photographing Small Subjects. Each different aspect of the natural scene requires slightly different tools and techniques for photographic success. If your interest is primarily in flowers, fungi or small insects, you will need a macro lens or some other means of getting close enough to your subject: a bellows unit or extension tubes will get you as close as you need to fill the frame using your normal lens. A sturdy tripod is a must in this kind of work, especially if you shoot with slow color films.

Slow, daylight-balanced color films will give you the richest saturation and best color rendition of your subjects. If you are making pictures of objects whose texture is important to the success of the picture, shoot in the afternoon or early morning, when the light is at an angle that sets off the texture best. Try photographing the same plants and flowers at different times of day as well; certain plants will change their shape and color as the illumination, heat and humidity changes. A data back attached to your Minolta will help you keep track of the sequence of exposures. If you own an X-700 camera, the accessory Multi Function back will not only imprint information on each frame, but can be made to fire the camera for you at predetermined intervals. This device makes time-lapse photography both simple and automatic.

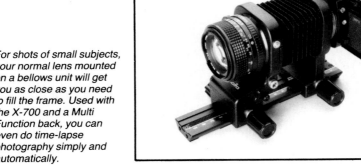

For shots of small subjects, your normal lens mounted on a bellows unit will get you as close as you need to fill the frame. Used with the X-700 and a Multi Function back, you can even do time-lapse photography simply and automatically.

It is not necessary to go far from home to photograph exotic wildlife. Your local zoo can provide you with excellent subjects in safe settings. Telephoto lenses will enable you to throw distracting or inappropriate backgrounds out of focus. Photo: M. & C. Werner.

Photographing Larger Subjects. Photographing animals poses an entirely different set of challenges. You will need longer focal length lenses, medium-speed or fast films, and a great deal of patience. You should know something about the life and habits of the creatures you are interested in photographing, as well. In many cases, a little creative camouflage on your part will help you get the pictures you are after. This does not mean that your local birds, rabbits, chipmunks and deer can only be photographed with the aid of complicated blinds, special human-scent masking oils and other specialized gear; but you will be more successful if you dress in muted earth tones, keep as quiet as possible, and make no sudden or unnecessary moves. A moderate tele-photo in the 200–300mm range will let you stay far enough away so as not to frighten off your subjects. Patience is the main ingredient of successful animal photography; it may take hours of waiting for your subjects to get used to your presence enough to go about their business. A remote-firing device such as the Minolta Wireless Controller IR-1

will let you release the shutter via infrared signals from distances up to 60 meters (200 ft) away, lessening the chance of your scent scaring off the animals.

If your nature photography interests are more generalized, you will need no more than your normal lens, a camera body and some medium-speed film to capture woodland or park scenes at different times of the day: the ethereal quality of sunlight filtering through the trees, the sparkle of morning dew on ferns and leaves and various other pictorial possibilities can be realized with a minimum of equipment or bother. Remember that, all other things being equal, you will get the best results from the slowest films. Use a tripod whenever possible to avoid camera shake, no matter what speed your film is; you might be pleasantly surprised at how much sharper your pictures look if you shoot on a sturdy camera support even at high shutter speeds.

It is not necessary to use a blind or any complicated equipment for photographing most wildlife. However, stillness and silence are important, as birds and animals in the wild as skittish. To remain as unobtrusive as possible, use a tripod-mounted camera and a shutter-release cable. An infrared remote-firing device will allow you to maintain an even greater distance from your subject. Photo: J. Isaac.

Closeup Photography

There are a number of ways you can make large, frame-filling photographs of the tiny objects all around you—seeds, small machine parts, details of postage stamps, the pistils and stamens of flowers, and so on. The easiest and least expensive way is to buy one or two closeup lens attachments. These are filter-like pieces of glass that are curved in such a way as to effectively shorten the focal length of the lens you put them on. This allows you to focus the lens closer than you could without the attachment in place. As you get closer, your image gets bigger. The closeup lenses are available in a variety of strengths; the higher the number, the closer the device will let you focus. Combining two of them will let you focus closer still, but with a loss in picture sharpness. You should not try to use more than two closeup lenses at once; the result will be too unsharp. You can use these devices with any focal length lens; most photographers use them with a normal lens, for occasional closeup work.

At the close focusing distances required to fill the frame with extremely small subjects, such as this locust, depth of field is quite limited. Use the smallest possible aperture your subject and the lighting will allow. The camera should be well supported, preferably on a sturdy tripod, and a cable release should be used to minimize camera movement. Photo: M. Fairchild.

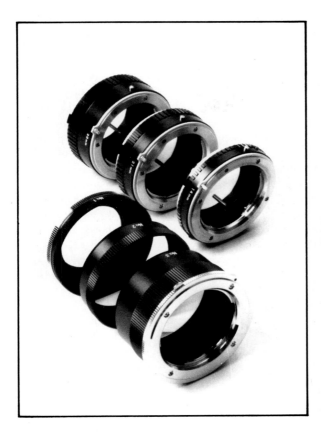

A set of extension tubes provides an easy and relatively inexpensive way to get close to your subject. Mounted between the camera body and the lens, they may be used singly or in combination. At top of picture is a set of Minolta's MC Auto Extension tubes, which allow full exposure automation and viewing of the subject at full aperture. The Extension Tube Set II (also shown) also provides accurate exposure automation but must be manually stopped down for metering.

A more controllable way of getting closer to your subject is with a set of extension tubes. These do not add any glass elements to your lens; they mount between the camera body and lens to extend the lens's near focus range. The results you will get with extension tubes will be sharper than those closeup lenses will give you. Minolta makes a series of automatic extension tubes for its SLRs that allow full exposure automation and viewing of the subject at full aperture. There is also a less expensive manual set, which still provides accurate exposure automation in the aperture priority mode; but the lens must be manually stopped down for metering. Either series of tubes can be used singly or in combination (though you cannot combine pieces of the manual set with those of the automatic set); the longer the tube, the closer the focusing distance and higher the subject magnification. You will find it easier to focus the lens/tube combination by moving the assembly back and forth slightly in relation to your subject, rather than trying to focus the lens in the normal fashion.

For more ease in focusing and versatility, along with a higher degree of magnification, there are bellows units. One of these—the Auto Bellows III—turns your Minolta SLR into a miniature view camera: it has a lens and camera stage that can be moved independently of one another to adjust for distortion and create various effects you could not get any other way. With a 50mm lens mounted on it, the Auto Bellows III can provide magnifications of up to 3.79 times life size.

Using a conventional lens on a bellows unit makes it impossible to focus at infinity. The bellows/lens combination keeps the rear element of the lens too far away from the film to make this possible. There are special lenses with no built-in focusing mechanisms that do allow infinity focus when mounted on a bellows. These greatly extend the focusing range of a camera/bellows/lens combination, and are specially formulated to provide excellent results at extremely close focusing distances.

Another type of bellows lens is the true macro lens, (sometimes called "micro"). Some of these come in extremely short focal lengths, providing astonishing degrees of image magnification. The Minolta 12.5mm Bellows Micro lens, for example, will let you produce an image that is 20.5 times life size. These specialized lenses are expensive, but allow pictures to be made of such esoteric things as the facets of a fly's eye.

Minolta's 12.5mm Bellows Micro lens provides an extraordinary degree of image magnification — up to 20.5X life size. For true macro work, a lens like this is essential, and well worth the price if this is an area where you want to concentrate.

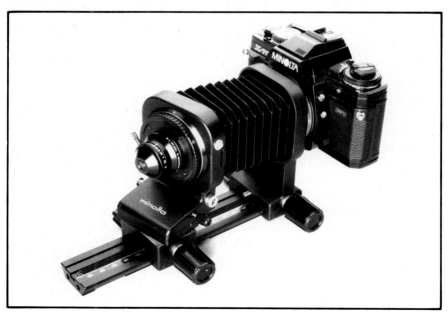

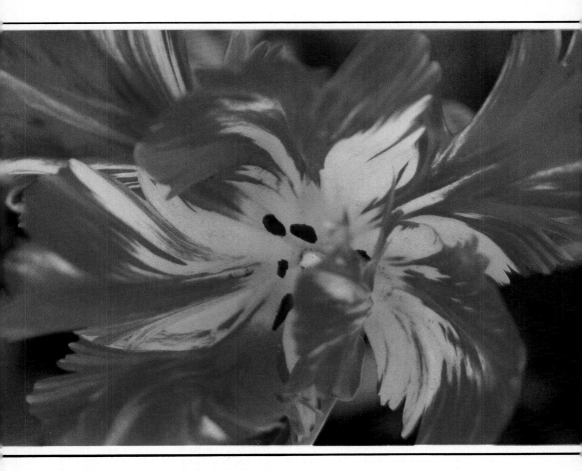

Closeups of large and showy blossoms are easy to take using any of the several lenses or closup attachments described in this section. Enlarged to 8" x 10" or larger, photographs like this make striking, semi-abstract wall hangings. Photo: J. Tomaselli.

More down-to-earth are the macro lenses described in chapter 2. These are designed for both general and closeup photography, and are the most versatile close-focusing lenses of all.

The keys to successful closeup photography are steadiness and sufficient depth of field. At extremely close focusing distances, depth of field is all but nonexistent at moderate apertures. Shoot at the smallest opening the lighting and your subject will allow; and use the sturdiest camera support available, along with a cable release. Minolta's electronic remote releases will let you fire your camera with the least amount of vibration possible.

Appendix

Minolta Camera Specifications

The Minolta XG-1

Type: 35mm single-lens reflex with automatic and full manual exposure control

Lens mount: Minolta SLR bayonet, 54° rotating angle; coupling for full-aperture metering and automatic diaphragm control with Minolta MD and MC lenses (Standard lenses MD 50mm f/1.2, f/1.4, f/1.7, or f/2)

Auto-exposure control: Special low-voltage, low-current computer circuit, actuated by contact or pressure on "touch switch" operating button, varies the shutter speed continuously and steplessly to yield proper exposure according to metering system indication at the aperture, film speed, and exposure adjustment set. Auto-exposure range: EV 2 to EV 17 (e.g., $\frac{1}{2}$ sec. at f/1.4 to 1/1000 sec. at f/11) at ISO 100/21° with f/1.4 lens

Shutter: Horizontal-traverse focal-plane type; electronically controlled speeds; 1/1000 to 1 sec., steplessly on automatic mode or in steps on manual mode

Metering: Full aperture TTL center-weighted averaging type, by two CdS cells mounted on either side of the eyepiece at the rear of the pentaprism

Film-speed range: ISO 25/15° to 160/33° set on the shutter-speed/function selector

Auto-exposure adjustment: Up to ±2 EV continuous adjustment of automatic exposure with $\frac{1}{2}$ EV click-stops and lock at "A" (zero setting)

Mirror: Oversize quick-return type

Viewfinder: Eye-level fixed pentaprism type showing 93% of 24 x 36mm film-frame area
Magnification: 0.87X with 50mm standard lens focused at infinity; Acute Matte-field focusing screen with central horizontally oriented split-image focusing surrounded by microprism band; stepless speeds indicated by 7 light-emitting diodes; LED over-/under-range indicators; LED at "60" position also blinks as flash-ready signal with the X-series Auto Electroflashes, manual-mode signal

Flash sync: PC terminal and hot shoe for X-sync. (disconnect when unit not installed); Electronic flash synchronizes at 1/60 sec. and slower step or stepless speeds: Class MF, M, FP flashbulbs synchronize at 1/15 sec. or slower speeds. Extra contact on hot shoe receivers signal from camera-control contact of the X-series Auto Electroflashes

Film advance: Motorized: Through built-in coupler key with accessory Auto Winder G
Manual: By lever with single 130° stroke after 30° unengaged movement
Film-advance release button for rewinding; advancing-type frame counter and Safe Load Signal that indicates film loading and advancing conditions

Power: Two 1.5v alkaline-manganese (Eveready A-76 or equivalent) or 1.55v silveroxide (Eveready EPX-76/S-76 or equivalent) cells power both auto exposure control and shutter's electronically governed operation
LED battery check indicator lights when operating switch in battery check position
Shutter will not release when voltage too low for proper operation

Self-timer: Electronic, LED indicated types; approximately 10 sec. delay

Other: 4-slot take-up spool; back cover with memo holder and ASA-DIN conversion table; integral grip

Size and weight: 52 x 89 x 138mm ($2\frac{1}{16}$ x $3\frac{1}{2}$ x $5\frac{7}{16}$ in.) 500g ($17\frac{5}{8}$ oz.) without lens and power cells

The Minolta XG-A

Type: 35mm single-lens reflex with automatic aperture-priority exposure control

Lens mount: Minolta SLR bayonet, 54° rotating angle; coupling for full-aperture metering and automatic diaphragm control with Minolta MD and MC lenses

Auto-exposure control: Special low-voltage, low-current computer circuit, actuated by contact or pressure on "touch switch" operating button, varies the shutter speed continuously and steplessly to yield proper exposure according to metering system indication at the aperture, film speed, and exposure adjustment set. Auto-exposure range: EV 2 to EV 17 (e.g., $\frac{1}{2}$ sec. at f/1.4 to 1/1000 sec at f/11) at ISO 100/21° with f/1.4 lens

Shutter: Horizontal-traverse focal-plane type; electonically controlled speeds: 1/1000 to 1 sec., steplessly on automatic mode

Metering: Full-aperture TTL center-weighted averaging type, by two CdS cells mounted on either side of the eyepiece at the rear of the pentaprism

Film-speed range: ISO 25/15° to 1600/33° set on the shutter-function selector

Auto-exposure adjustment: Up to ± 2 EV continuous adjustment of automatic exposure with $\frac{1}{2}$ EV click-stops and lock at "AUTO" (zero setting)

Mirror: Oversize quick-return type

Viewfinder: Eye-level fixed pentaprism type showing 93% of 24 x 35mm film-frame area
Magnification: 0.88X with 50mm standard lens focused at infinity; Acute Matte focusing screen with central horizontally oriented split-image focusing spot surrounded by microprism band; stepless speed indicated by 7 light-emitting diodes; LED over-/under-range indicators; LED at "60" position also blinks as flash-ready signal with the X-series Auto Electroflashes

Flash sync: Hot shoe for X sync (disconnects when unit not installed); Electronic flash synchronizes at 1/60 sec.

Extra contact on hot shoe receives signal from camera-control contact of the X-series Auto Electroflashes

Film advance: Motorized: Through built-in coupler key with accessory Auto Winder G

Manual: By lever with single 130° stroke after 30° unengaged movement

Film-advance release button for rewinding; advancing-type frame counter and Safe Load Signal that indicates film loading and advancing conditions

Power: Two 1.5v alkaline-manganese (Eveready A-76 or equivalent) or 1.55v silver oxide (Eveready EPX-76/S-76 or equivalent) cells contained in camera base power both auto exposure control and shutter's electronically governed operation.

LED battery check-indicator lights when operating switch in battery check position

Shutter will not release when voltage too low for proper operation

Self-timer: Electronic, LED indicated types; approximately 10 sec. delay

Other: 4-slot take-up spool.

Size and weight: 52 x 88 x 138mm (2 x 3^7/$_{16}$ x 5^5/$_8$ in.) 485g (17^1/$_8$ oz.) without lens and power cells

The Minolta X-700

Type: Electronically governed 35mm single-lens reflex AE camera

Exposure-control modes: Fully programmed ("P"), aperture-priority automatic ("A"), and metered manual ("M")

Lens mount: Minolta SLR bayonet of integrally lubricated stainless steel (54° rotating angle); coupling for full-aperture metering, finder display input, and automatic diaphragm control, providing programmed or aperture-priority auto operation with Minolta MD lenses, aperture-priority auto operation with MC and other Minolta SLR interchangeable lenses/accessories; spring-return button for depth-of-field preview or stop-down meter readings with other than MC or MD lenses (standard lenses: MD 50mm f/1.2, f/1.4, f/1.7 or f/2)

Exposure control and functions: Low-voltage, low-current computer circuit incorporating quartz crystal for sequential control to 1/30,000-sec. accuracy, large-scale ICs, samarium-cobalt impulse-release magnets, and linear-resistance inputs) varies both aperture and shutter speed steplessly according to special "faster-speed" program in P mode, or varies shutter speed steplessly according to aperture set in A mode, to yield proper exposure for the film speed and exposure adjustment set; auto-exposure range: EV 1 to EV 18 (e.g., 1 sec. at f/1.4 to 1/1000 at f/16) at ISO 100/21° with f/1.4 lens; AE-lock device holds meter reading for exposure at that value regardless of subject-brightness changes.

Shutter: Horizontal-traverse focal-plane type; electronically controlled stepless speeds 1/1000 to 4 sec. set automatically with endlessly rotatable selector dial locked at "P" or "A" setting or speeds 1 to 1/1000 sec. or "B" (bulb) set manually at detented dial indications; electromagnetic shutter release locks when voltage too low for proper operation.

Metering: TTL center-weighted averaging type, by silicon photocell mounted at rear of pentaprism for available light, measured full aperture for normal finder display, then at taking aperture for programmed/automatic-exposure setting/determination or stop-down display; by another SPC mounted with optic in side of mirror compartment for off-the-film light at taking aperture during exposure to control dedicated flash duration.

Film-speed range: ISO 25/15° to 1600/33° set by dial that locks at 1/$_3$-EV increments

Exposure-adjustment control: Up to ± EV continuous adjustment of P, A, or M exposure by dial that locks at zero position and each 1/$_2$-EV setting

Mirror: Triple-coated oversize instant-return slide-up type

Viewfinder: Eye-level fixed pentaprism type showing 95% of 24x36mm film-frame area; magnification: 0.9X with 50mm standard lens focused at infinity; power: -1D, adjustable with accessory snap-on eyepiece lenses; Fresnel-field focusing screen having artificially regular-patterned matte field plus central split-image horizontally oriented focusing aid surrounded by microprism band, interchangeable with Type P1, P2, Pd, M, G, L, S, or H screens at authorized Minolta service stations; visible around frame: mode indication (P, A, or M), shutter-speed scale (1, 2, 4, 8, 15, 30, 60, 125, 250, 500, and 1000) with LED setting indication, triangular over-/underrange LED indicators blinking at 4Hz, flash-ready signal (LED next to "60" blinking at 2Hz), FDC signal ("60" LED blinking at 8Hz for 1 sec. after correct flash exposure), mis-set lens warning (mode indication blinking at 4Hz) in P mode, battery check (by glowing of any LED when operating button touched or pressed slightly), f-number set with MD or MC lenses, and exposure-adjustment engaged indication (LED blinking at 4Hz); display and metering activated by normal finger contact or slight pressing of operating button and continue for 15 sec., except go out after shutter release

Flash sync: PC terminal and hot shoe for X sync (disconnected when no unit installed); electronic flash ("strobe") synchronizes at 1/60 sec. and slower stepless or fixed speeds or "B" setting; Class MF, M, and FP flashbulbs, at 1/15 or slower settings; additional spring-loaded contacts on hot shoe for camera/flash control and finder indication in programmed automatic operation.

Film advance: Manual: by lever with single 130° stroke after 30° unengaged movement; motorized: through built-in coupler key with accessory Motor Drive 1 or Auto Winder G; release button for rewind on camera bottom; advancing-type frame counter; Safe Load Signal indicates film loading and advancing condition.

Power: Two 1.5v alkaline-manganese (Eveready A-76 or equiv.) or 1.55v silver-oxide (Eveready S-76, EPX-76, or equiv.) cells contained in camera base power both programmed/auto exposure control and manual operation; three-position main switch with indication for off, on, or with audible piezoelectric slow-speed warning and self-timer operating indication; battery check by touching or slightly pressing operating button (LEDs do not light when cells approach exhaustion); shutter will not release when voltage too low for proper operation.

Self-timer: Electronic for 10-sec. delay, with operation indicated by camera-front LED that blinks at 2Hz for

8 sec., then 8Hz for 1 sec., then remains on until shutter releases, plus simultaneous audible indication when main switch in appropriate position; engaged by switch on body, cycle started by pushing operating button, cancelable anytime before release.

Other: Audible 4Hz piezoelectric warming when finder speed indication is $1/30$ sec. or slower whenever finger contacts "touch switch" normally or presses operating button slightly with main switch appropriately set; integral front handgrip; detachable back with integral handgrip, memo holder, and ISO, DIN, ASA conversion table; positive 4-slot take-up spool; remote shutter-release socket.

Size: and weight: 51.5 x 89 x 137mm (2 x 3^1/$_2$ x 5^3/$_8$ in.), 505g (17^{13}/$_{16}$ oz.) without lens and/or power cells.

The Minolta X-570

Type: Quartz/electronically governed 35mm single-lens reflex auto-exposure (AE) camera
Exposure-control modes: Aperture-priority automatic ("A") and match-LED manual ("M")

Lens mount: Minolta SLR bayonet of integrally lubricated stainless steel (54° rotating angle); coupling for full-aperture metering, finder display input, and automatic diaphragm control, providing aperture-priority AE with virtually all Minolta SLR interchangeable lenses/accessories; spring-return button for depth-of-field preview or stop-down meter readings with other than MC or MD lenses (standard lenses; MD 50mm f/1.2, f/1.4, f/1.7, or f/2)

Exposure control and functions: Low-voltage, low-current computer circuit (incorporating quartz crystal with constant frequency of 1/32, 768 sec. for digital sequential and shutter-speed control, digital and analog LSIs, samarium-cobalt impulse-release magnets, and linear-resistance inputs) varies shutter speed steplessly according to aperture set in "A" mode, to yield proper exposure for film speed set; auto-exposure range: EV 1 to EV 18 (e.g., 1 sec. at f/1.4 to 1/1000 at f/16) at ISO 100/21° with f/1.4 lens; AE lock enables holding meter reading for exposure at that value regardless of subject-brightness range.

Shutter: Quartz-controlled horizontal-traverse focal-plane type; stepless speeds 1/1000 to 4 sec. set automatically with endlessly rotatable selector dial locked at "A" setting or fixed speeds 1 to 1/1000 sec. or "B" bulb set manually at detented indications; electromagnetic shutter release locks when voltage too low for proper operation.

Metering: TTL center-weighted averaging type, by silicon photocell mounted at rear of pentaprism for available light measured full aperture with MD or MC lenses and accessories or at stop-down aperture with non-meter-coupled lenses or accessories; by another SPC mounted with optic in side of mirror compartment for through-the-lens (TTL) off-film light at taking aperture during exposure to control burst duration of PX-series flash units.

Film-speed range: ISO 12/12° to 3200/36° set by dial that locks at $1/3$-EV increments

Mirror: Triple-coated oversize instant-return slide-up type

Viewfinder: Eye-level fixed pentaprism type showing 95% of 24 x 36mm film-frame area; magnification: 0.9x with 50mm standard lens focused at infinity; power: −1D, adjustable with accessory snap-on

eyepiece lenses; Fresnel-field focusing screen having artificially regular-patterned matte field plus central split-image horizontally oriented focusing aid surrounded by microprism band, interchangeable with Type P1, P2, Pd, M, G, L, S, or H screens at authorized Minolta service stations; visible around frame: mode indication ("A" or "M"), shutter-speed scale (1, 2, 4, 8, 15, 30, 60, 125, 250, 500, 1000) with LED setting indication (glowing LED or LEDs for metered speed in "A" and "M" mode; LED blinking at 4 Hz opposite manually set speed for match-LED manual), 1–4 sec. auto-speed indication (underrange LED glows), triangular over-/under-range LED indicators blinking at 4Hz, "B" setting indication (* next to "B" on scale lights up), flash-ready signal (LED next to "60," AE-locked slower speed, or "B" blinks at 2Hz), FDC signal (LED next to "60" or AE-locked slower speed blinks at 8Hz for 1 sec. after correct flash exposure with PX flash units), battery check (by blinking of mode indicator when cells near exhaustion; no LEDs light when cells exhausted), f-number set with MD or MC lenses; display and metering activated by normal finger contact or slight pressing of operating button and continue for 15 sec. after finger removed, except to go out during exposure.

Flash sync and control: Hot shoe (disconnected when no unit attached) and PC terminal for X sync; spring-loaded camera-control contact on hot shoe for automatic setting of shutter at 1/60 sec. (except when AE lock engaged for sync at slower auto speeds or mode/shutter speed selector set for sync at "B") and flash-ready signaling with PX and X units; other electronic units synchronize at 1/60 sec. and slower manual speeds or "B" setting; Class MF, M, and FP flashbulbs, at 1/15 sec. or slower settings; second spring-loaded contact on hot shoe for burst control by Direct Autoflash Metering and FDC signaling with PX units.

Film advance: Manual: by lever with single 130° stroke after 30° unengaged movement; motorized: through built-in coupler key with accessory motor Drive 1 or Auto Winder G; release button for rewind on camera bottom; advancing-type frame counter; Safe Load Signal indicates film loading and advancing condition.

Power: Two 1.5V alkaline-manganese (LR44: Eveready A-76 or equiv.), two 1.55v silver-oxide (SR44: Eveready X-76, EPX-76, or equiv.), or one 3v lithium (CR-1/3N) cells contained in camera base power both auto exposure control and manual operation; three-position main switch with indication for off, on, or on with audible piezoelectronic slow-speed warning and self-timer operating indication; battery check by touching or slightly pressing operating button (mode LED blinks when cells approach exhaustion); no LEDs light and shutter will not release when voltage too low for proper operation

Other: Audible 4Hz piezoelectric warning when auto speed is 1/30 sec. or slower whenever finger contacts "touch switch" normally or presses operating button slightly with main switch appropriately set; integral front handgrip; detachable back with integral handgrip, memo holder, and ISO (ASA/DIN) table; positive 4-slot take-up spool; remote shutter-release socket

Size and weight: 51.5 x 89 x 137mm (2 x 3^1/$_2$ x 5^3/$_8$ in.), 505g (17^3/$_{16}$ oz.) without lens and/or power cells.

Standard accessories: Carrying strap with slide-on spare battery holder and eyepiece cap.

Index